IMAGES
of America
RADFORD

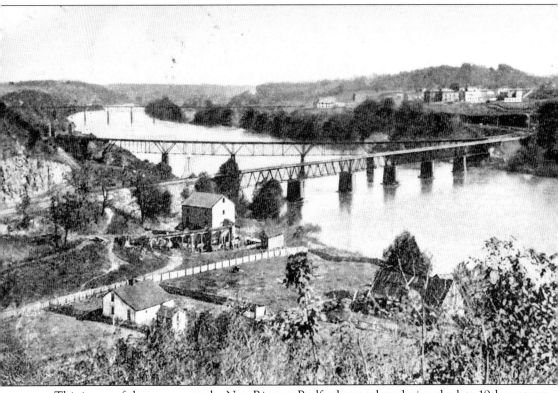

This image of the spans over the New River at Radford was taken during the late 19th century. The unusual curved railroad bridge was completed in 1888, and its use was discontinued in 1900 when a new rail line was created. The straight railroad bridge was destroyed by Union troops during the Civil War and later rebuilt. (Courtesy of Mayor Thomas L. Starnes.)

ON THE COVER: Norfolk and Western steam locomotive No. 29 heads up a passenger train parked in the west end of Radford in 1893. This delightfully composed photograph was taken by notable Radford photographer William W. Darnell. (Courtesy of William Simpson.)

IMAGES of America
RADFORD

John W. Barksdale

Copyright © 2007 by John W. Barksdale
ISBN 978-0-7385-4442-7

Published by Arcadia Publishing
Charleston, South Carolina

Printed in the United States of America

Library of Congress Catalog Card Number: 2007920760

For all general information contact Arcadia Publishing at:
Telephone 843-853-2070
Fax 843-853-0044
E-mail sales@arcadiapublishing.com
For customer service and orders:
Toll-Free 1-888-313-2665

Visit us on the Internet at www.arcadiapublishing.com

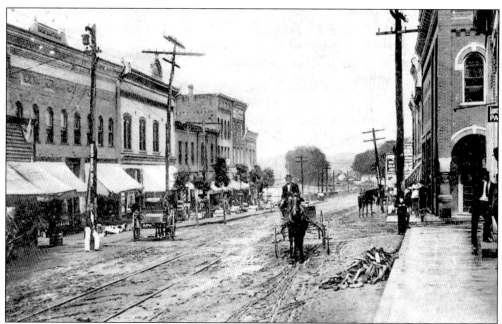

While still in its infancy, the city of Radford took on a look that remains similar to that of today. This classic image of the east end business district provides a glimpse of life during the gay 1890s. (Courtesy of Mayor Thomas L. Starnes.)

Contents

Acknowledgments		6
Introduction		7
1.	Early History	11
2.	The Railroad	19
3.	Industry	29
4.	Business	39
5.	Education	61
6.	Buildings, Churches, and Homes	73
7.	People	91
8.	Town and Country	109

ACKNOWLEDGMENTS

I want to thank everyone who has made the effort to assist in the process of completing this book. Without your help, this work would not have been possible. The board members of the Radford Heritage Foundation; Hanns-Peter Nagel, the director of Glencoe Museum; and the volunteers who devote time to Glencoe Museum all deserve very special thanks. Other people and organizations instrumental in the creation of this work include the following: Mary Anne Barksdale, Dr. Mary Alice Barksdale, Ken and Jane Farmer, Mayor Thomas L. Starnes, Sarah Carter, A. C. Wilson, and Brack Stovall. The archives of the Radford Heritage Foundation, the Library of Congress, Radford University, Virginia Polytechnic Institute, and the Radford Public Library were all vital sources for information and images included in this book. The photograph contributors are too numerous to thank individually; therefore, I want to express my general gratitude to all who are credited in the captions. Without your willingness to assist by providing quality images, this pictorial history of Radford would not be complete.

INTRODUCTION

Long before the coming of European immigrants, humans inhabited the area that now encompasses the city of Radford. In 1974, archeologists and local volunteers found the remains of a Native American settlement that dates back to the early 17th century. This archeological dig on the Trigg Site confirmed that the fertile river bottomland in the area now known as Bisset Park was home to a group of Native Americans.

Early development of the Radford area was related to the establishment of the Wilderness Road, a frontier trail that was the main route used by settlers to reach areas in Tennessee and Kentucky during the latter period of the 18th century. Most explorers and settlers using this path were on foot or horseback. The Wilderness Road crossed the New River in what is now Radford. In 1762, the Ingles family established Ingles Ferry, which enabled travelers on the Wilderness Road to cross the New River. William Ingles and Mary Draper Ingles were among the first European settlers in southwest Virginia. Before the establishment of Ingles Ferry, Mary Draper Ingles was held captive by a group of Shawnee Indians in 1755. She was taken to Chillicothe, a tribal settlement on the Scioto River in Ohio. Ingles eventually escaped from captivity and was able to follow the Ohio and New Rivers back to the area.

The Wilderness Road was gradually improved over time and, by the dawn of the 19th century, was known as the Stagecoach Road. Rock Road, which runs along the south side of Radford, is actually a part of the old Stagecoach Road. In 1796, John Heavin established Lovely Mount Tavern, an inn for travelers just a few miles east of Ingles Ferry near the crossing of Connolly's Run on the Stagecoach Road. Gradually, a small community was established in the area then known as Lovely Mount, complete with a church and post office.

Dr. John Blair Radford moved to Lovely Mount in 1836 and started a medical practice. He was one of the few practicing physicians in the area during this period. Dr. Radford had his home built on a hillside overlooking the river. Completed around 1838, his new home was dubbed Arnheim, which means "home of the eagle" in German and is in reference to its spectacular view of the New River. It is unknown exactly why the city was named after Dr. Radford. Townspeople began referring to the area as Radford a few years after his death in 1872. Perhaps the naming of the city was a result of this early settler's generosity as a doctor and evenhandedness as a businessman.

In 1854, the Virginia and Tennessee Railroad established a depot near Lovely Mount. The location was called Central because it sat halfway between Lynchburg and Bristol. The establishment of Central Depot had a major effect on development and the eventual establishment of the city of Radford. The coming of the railroad enabled other industries to be launched nearby such as a foundry, quarry, brickworks, knitting mill, and lumberyard.

The city of Radford was officially incorporated on January 22, 1892, and chartered with a mayor-council structure of government. Connolly's Run separated the city into east and west ends; an informal rivalry between the two areas ensued and still exists to some extent today. The east end was primarily a rail and commercial center with railroad shops, a roundhouse, a switching yard, and a depot, while the west end was more focused on industry. Other significant events that took

place in 1892 were the opening of the Wagon Bridge across the New River and the establishment of St. Albans School for Boys at the head of the new bridge on a hill in North Radford (now Fairlawn). The Radford Pipe Works (the foundry) also began production in 1892.

The 1890s began as a prosperous time for Radford; however, a nationwide depression that hit in 1894 slowed the city's growth considerably. Several other catastrophic events took place during the last decade of the 19th century. On March 16, 1893, the Radford Inn caught fire and a bridge over Connolly's Run collapsed at about the same time, wreaking havoc. A devastating fire destroyed most of the businesses on the south side of the east end business district on Christmas Eve 1896. Then, on May 31, 1897, an earthquake originating in Giles County shook all of southwest Virginia including Radford. Reports from Radford stated that the earth was moving in waves. Many chimneys were broken, and people were terrified and screaming in the streets. The quake evidently created quite a scare, though only a small amount of property damage actually occurred in Radford.

During the early part of the 20th century, industry began to flourish in and around Radford. Many new industrial enterprises were established during this period such as the Norfolk and Western timber preserving plant, West End Milling, the Clover Creamery, Burlington Mills, the Old Colony Box Company, and the Radford Ice Manufacturing Company. Along with industry, new businesses were established to serve the needs of the growing population. By the late 1920s, Radford was home to a total of 84 retail and wholesale establishments, including three hotels, three banks, and two theaters. By 1930, the population of the growing city was around 6,000.

In 1913, Radford Normal School, later to become Radford University, was founded as a women's college focusing on teacher education. The university prospered and has since become a major employer in Radford.

Automobile transportation was changing the face of America in the early 20th century, making paved roads crucial for the progress of any city. A group of Radford citizens were successful in lobbying for the new east-west federal highway to pass through Radford. Lee Highway, U.S. 11, was completed in the 1920s with a positive economic impact on the city.

The Great Depression of the 1930s slowed growth in the area, just as it did elsewhere. By the late 1930s and early 1940s, however, Radford was experiencing a great upswing in its economy. The first major event was the construction of Claytor Dam, beginning in 1937 and ending in 1939. Following completion of the dam, work began on the Radford Ordinance Works (now known as the Radford Army Ammunition Plant) in 1940. The facility opened on April 5, 1941, with an initial workforce of around 23,000 people. The plant had a boomtown effect on Radford. Along with the Radford Army Ammunition Plant, three new federally funded housing developments—Radford Village, Sunset Village, and Monroe Terrace—were constructed in Radford at this time. Additionally, a private housing project was underway in North Radford called Fairlawn. Fairlawn later became a separate community across the New River in Pulaski County.

By 1943, the population of Radford had grown to around 12,000. This great increase in population was taxing to the city's infrastructure, and rapid changes were necessary. Housing was the most urgent problem, and residents who had space boarded workers in their homes. The police force was enlarged, and the school system hired more teachers. The Radford Recreation Center, dedicated on May 16, 1942, was a WPA venture designed to increase recreation opportunities. An area was provided within the new recreation center for the establishment of a much-needed public library.

The city lacked adequate medical care for its burgeoning population until 1941, when the Radford Community Hospital opened on Tyler Avenue in the building that is now the Avalon Apartments. This facility was not large enough to suit the growing need for medical care caused by the influx of new workers and was considered a stopgap measure. In the early 1940s, Congress allocated funds for new hospitals in locations designated as defense areas through the Lanham Act. Radford Community Hospital applied for the program and was granted the monies to build a new hospital on the corner of Eighth and Randolph Streets in the west end. The new hospital opened on September 18, 1943.

During the immediate postwar era, the boom was over in Radford. The city had grown immensely during the war, yet the population actually decreased during the late 1940s. Residency began a slow but steady climb in the 1950s due in part to the fact that the Korean War effort had increased employment opportunities at the Radford Army Ammunition Plant. Beginning in the late 1950s, several new industries came to Radford, including the Inland Motor Division of the Kollmorgen Corporation, the Graflo Rubber Company, the Kenrose Manufacturing Company, and the RADVA Plastics Corporation. In the early 1960s, Radford became an All-American City, a title awarded by the National Municipal League. Radford was the smallest city on the East Coast to receive the honor. Change came in 1965, when the section of Interstate 81 running south of Radford was completed, causing traffic to bypass the city. For the most part, traffic on U.S. 11 remains local, and the city has not built out toward the interstate.

The primary focus of this book is the period from the incorporation of the city in 1892 through the 1970s. During this time, Radford has had a variety of outward appearances. Beginning in the 19th century as Central Depot, Radford was initially a railroad town dominated by the Norfolk and Western, which was the primary means of employment other than farming. As the city progressed, industry began to take hold due in large part to the influence of the railroad and the abundance of natural resources in the area. Gradually, Radford became a predominantly blue-collar town with the majority of its inhabitants employed by local industries. Since the current tendency for this type of work is to be farmed out to developing nations overseas, and since rail has declined as a mode of transportation in this country (for both people and goods), Radford University now has a much higher status in regards to economic importance. Thus, the city has morphed into what many refer to as a "college town," where higher education is the primary product offered. This book is meant to be a pictorial history of the city that highlights people, places, and events, inducing the memories of longtime inhabitants while also introducing new residents to the city's proud legacy.

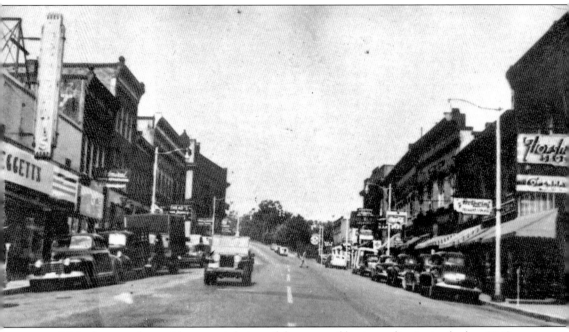

This photograph provides a partial view of the east end business district in the late 1940s, a time of prosperity for Radford merchants. The variety of shops brought in customers from surrounding rural areas and smaller communities. (Courtesy of the *Radford News Journal*.)

One

Early History

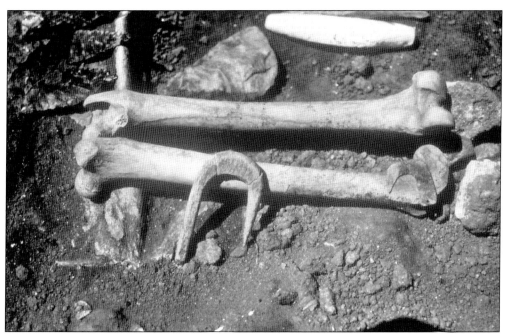

These artifacts were the belongings of the Native Americans who lived in Radford during the early part of the 17th century. The projectile points, stone knives, and fish hooks—made from deer antler and copper—were common items used for survival by the Native Americans inhabiting a settlement on the New River in what is now Bisset Park. Graham Simmerman found the artifacts lying just about how they are shown in this photograph during the Trigg Site excavation in 1974–1975. (Courtesy of Graham Simmerman.)

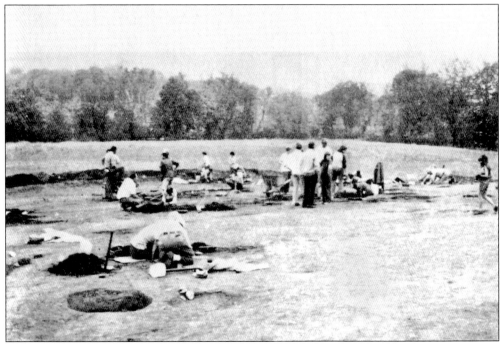

Many Radford residents participated in the excavation of the Trigg Site in 1974–1975. The artifacts found at this archeological site confirm that the area now known as Radford has been inhabited by humans for hundreds of years. (Courtesy of the Radford Heritage Foundation.)

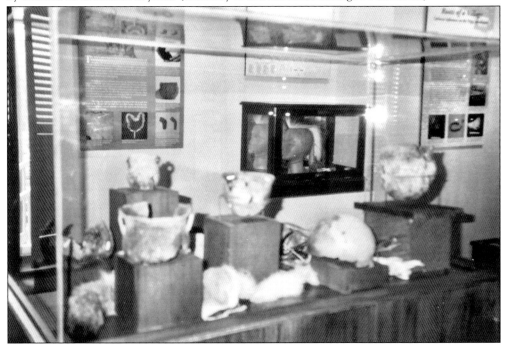

These Native American pottery pieces are part of the Trigg exhibit at Glencoe Museum in Radford. The objects were unearthed in 1974–1975, when the 17th-century Native American village was excavated. (Courtesy of the Radford Heritage Foundation.)

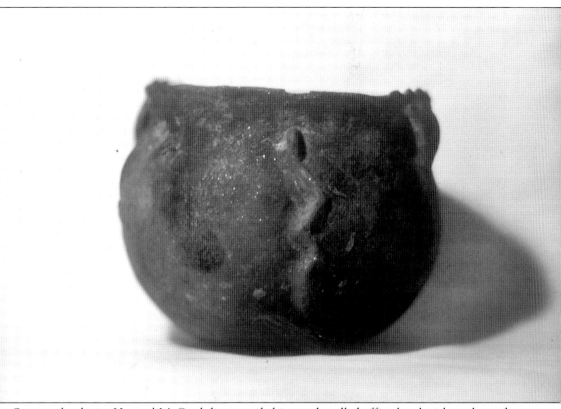

State archeologist Howard McCord discovered this two-handled effigy bowl with snake and turtle figures during the excavation of the Trigg Site. A variety of types and styles of pottery were unearthed, indicating that the local Native Americans traded with others and had a rich culture capable of producing stylishly crafted pottery. (Courtesy of Graham Simmerman.)

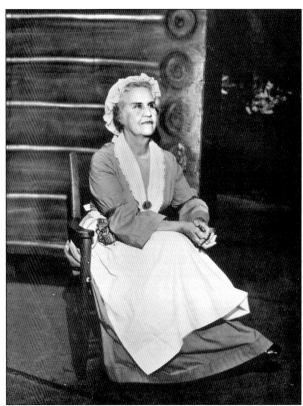

Mary Lewis Ingles Jeffries is dressed in costume for the role of Eleanor Harding Draper, her great-great-great-great-great-grandmother, in the theatrical production *The Long Way Home*. Eleanor Harding Draper was Mary Draper Ingles's mother. (Photograph by Earl Palmer; courtesy of Dr. Richard F. and Kathleen Harshberger.)

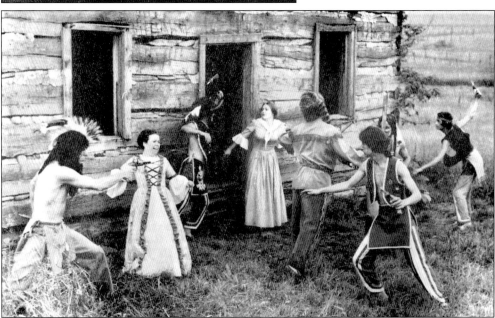

This scene from *The Long Way Home* depicts the moment when Mary Draper Ingles was captured by Shawnee Indians. The play was held annually in Radford on the Ingles farm, just north of the Interstate 81 bridge across the New River, from the early 1970s through the 1990s. (Photograph by Earl Palmer; courtesy of Dr. Richard F. and Kathleen Harshberger.)

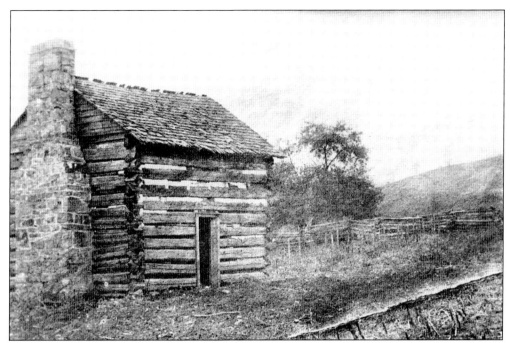

This cabin was constructed in 1755 by William Ingles. Mary Draper Ingles returned from Native American captivity in December 1755 and lived here for the rest of her life. William died in 1782 at the age of 56, and Mary in 1815 at the age of 84. (Courtesy of the Radford Heritage Foundation.)

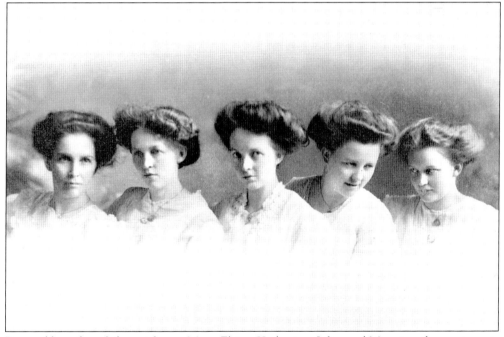

Pictured here from left to right are Mary, Elrica, Katherine, Julia, and Minnie—the great-great-granddaughters of pioneer heroine Mary Draper Ingles. No portrait of Mary Draper Ingles (1732–1815) exists; however, this image of her descendants provides some idea of how she may have looked. (Courtesy of the Radford Heritage Foundation.)

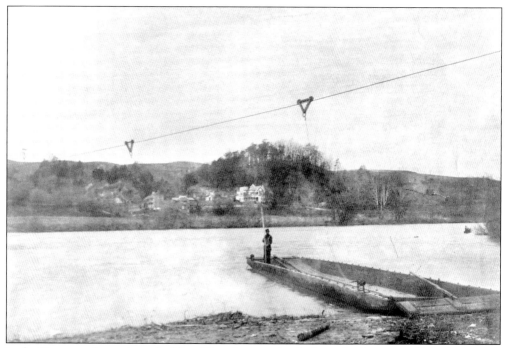

Ingles Ferry was located on the New River just north of where the Interstate 81 bridge is now situated. Established by Col. William Ingles in 1762, the ferry was an integral part of a frontier trail from Pennsylvania to Kentucky called the Wilderness Road. A covered bridge was constructed on the site in 1842; however, it was burned by retreating Confederate troops in 1864. The ferry was re-established after the Civil War and was in operation until 1948, when the boat overturned while transporting a truck. (Courtesy of the Radford Heritage Foundation.)

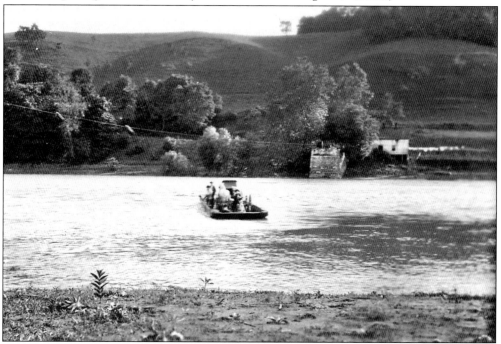

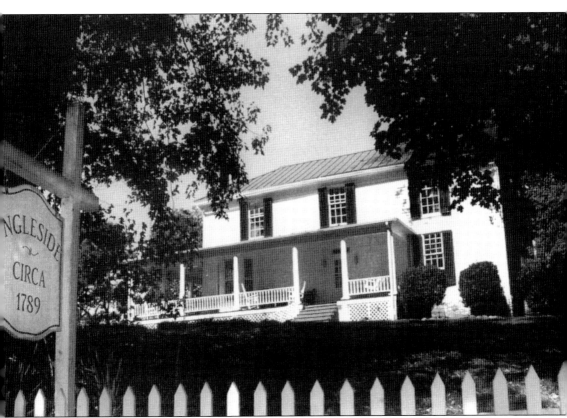

Aptly named Ingleside, this timber-frame home was built in 1789–1790 by Col. John Ingles, the son of William and Mary Draper Ingles. The elegant residence was very unique in an era when western Virginia was part of the American frontier and 99 percent of the settlers were living in log cabins. It is the oldest home in the city of Radford. (Courtesy of the Radford Heritage Foundation.)

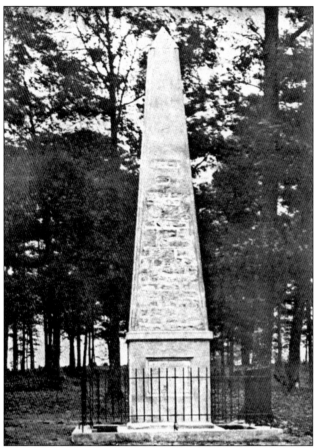

Located in the West View Cemetery, this monument was constructed with stones from the chimney of Mary Draper Ingles's cabin. The obelisk commemorates Mary's life and escape from captivity. The following is a quote taken directly from the plaque on the monument: "No greater exhibition of female heroism, courage and endurance are recorded in the annals of frontier history." (Courtesy of the Radford Heritage Foundation.)

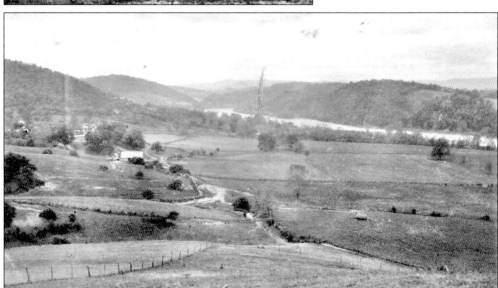

This early-1900s photograph depicts the Ingles farm and surrounding countryside. Nine generations of William and Mary Draper Ingles descendants have lived and farmed this land over the past 250 years. (Courtesy of the Ken and Jane Farmer Collection.)

Two
THE RAILROAD

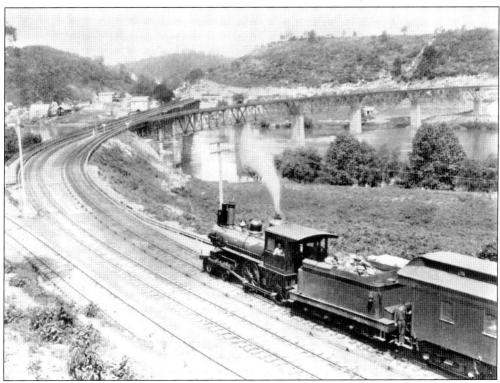

Norfolk and Western steam locomotive No. 30 pulls a passenger train to the west out of Radford in 1886. Also shown here are the two railroad bridges of the time. The straight bridge is still in use today; however, the curved span was discontinued in the early part of the 20th century because of changes to the line to eliminate a heavy grade. The old stone piers from the curved bridge remain in place and can be seen on the river. (Courtesy of the Norfolk and Western Historical Photograph Collection, Virginia Polytechnic Institute and State University.)

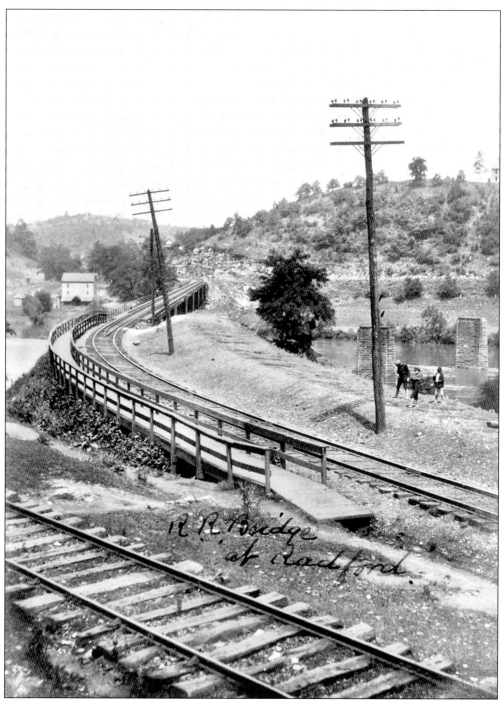

In this interesting view of the railroad bridge at Radford, three children play in the roadbed of the old curved bridge. The curved span had recently been removed from service when this photograph was taken in the early part of the 20th century. At the time, the railroad bridge included a pedestrian walkway. (Courtesy of the Ken and Jane Farmer Collection.)

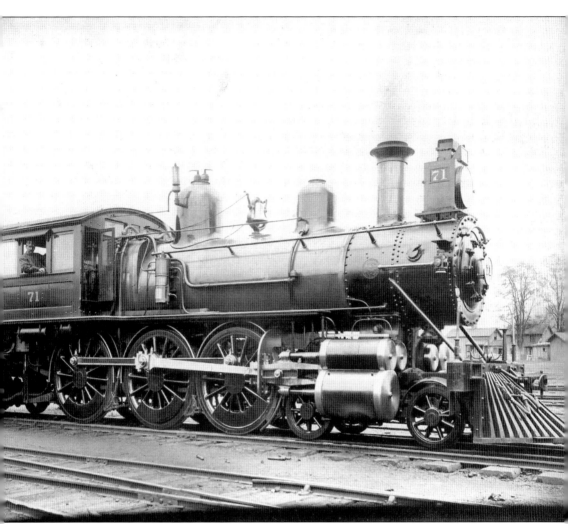

Norfolk and Western No. 71 appears in the rail yard at Radford in 1893. This 4-6-0 locomotive was built by the Baldwin Locomotive Works. When its Vauclain compound cylinders proved unreliable, the locomotive was later converted to a single-expansion engine with piston valves. (Courtesy of William Simpson.)

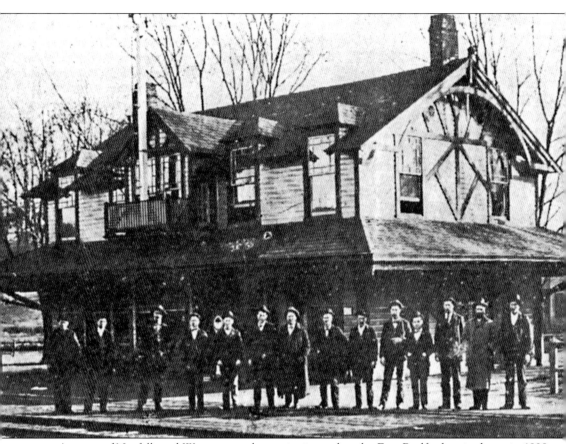

A group of Norfolk and Western employees is pictured at the East Radford train depot in 1898. During this period, stations were an integral part of the city because rail transportation brought much-needed commerce and tourism to the area. (Courtesy of the Harvey/Ingles Archives.)

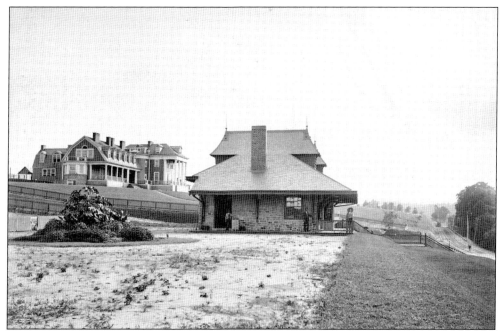

The Radford Inn (left) and the west end railroad station (center) are shown here in the 1890s. The inn was constructed in 1890–1891 and burned to the ground in 1893. The railroad immediately made plans to rebuild a new hotel on the site; however, those plans were never carried out. (Courtesy of the Radford Heritage Foundation.)

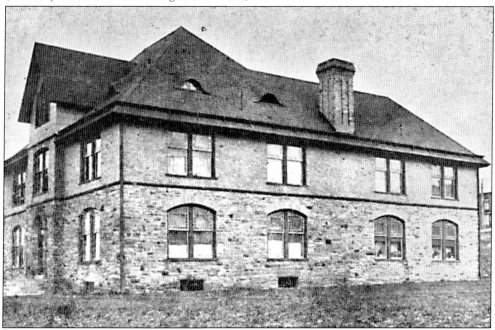

The Norfolk and Western division office, pictured before 1915, was located in the west end, just west of the New River Bridge at Radford. The railroad was a major employer during the late 19th and early 20th centuries, and its white-collar staff worked in this office. (Courtesy of the Harvey/Ingles Archives.)

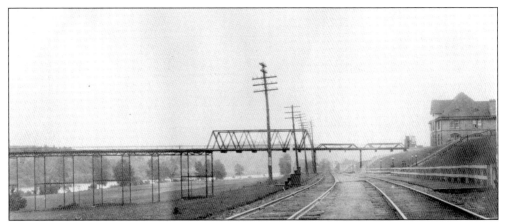

This photograph of the railroad tracks, the New River Bridge, and the Norfolk and Western division office was taken by someone standing on the tracks near the west end railroad station sometime around 1900. (Courtesy of the Ken and Jane Farmer Collection.)

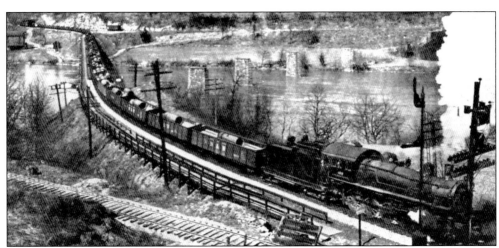

A Norfolk and Western train carries a load of iron pipe from the Radford Pipe Works in the 1930s. The bridge that the train is crossing is still in use by the Norfolk Southern Railroad. (Courtesy of the Radford Heritage Foundation.)

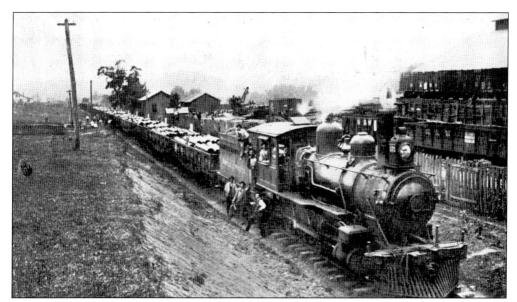

A train leaves Radford with a load of pipe destined for Panama. Pipe manufactured at the Radford Pipe Works was shipped to Panama for use in the construction of the Panama Canal during the years from 1904 to 1914. (Courtesy of the Harvey/Ingles Archives.)

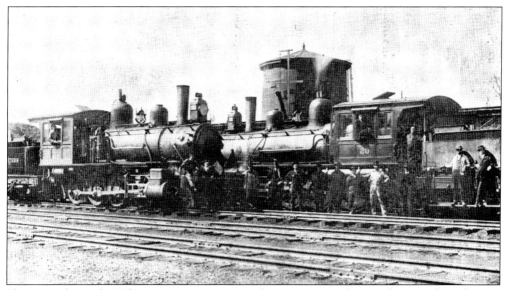

Shown in this early-20th-century image are two locomotives in the switching yard on the east end of Radford. The switching yard had 15 miles of track and four or five switch engines at the time. (Courtesy of the Harvey/Ingles Archives.)

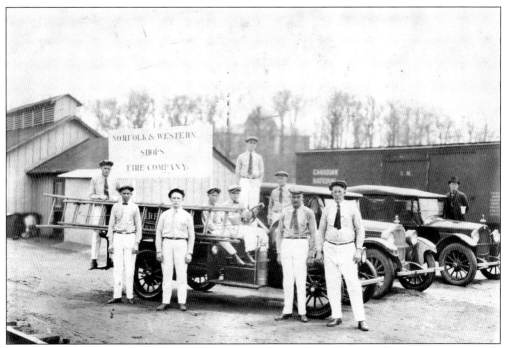

Radford's Norfolk and Western Shops Fire Company poses in front of a fire engine just outside the Norfolk and Western shop in the east end. Fire was a constant danger during the steam era of railroading, and a fire company was a necessity for the railroad. (Courtesy of the Ken and Jane Farmer Collection.)

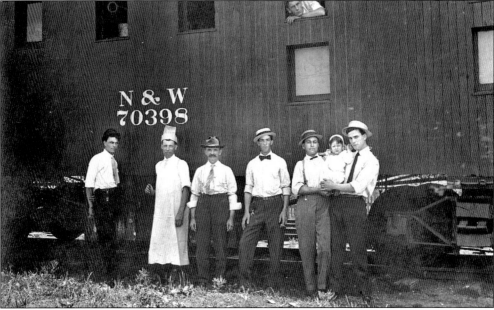

Norfolk and Western employees stand in front of bunk car No. 70398 in the Radford yard. Bunk cars were used for maintenance-of-way work, which necessitated the laborers to be away from their families for days at a time. The second man from the left was a cook. (Courtesy of the Radford Heritage Foundation.)

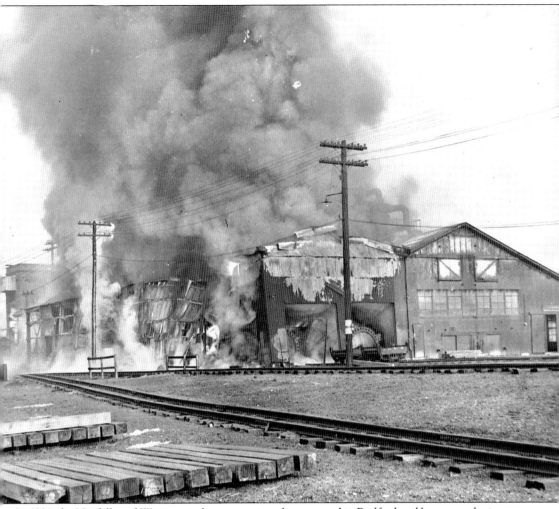

In 1921, the Norfolk and Western timber preserving plant opened in Radford and began producing creosoted railroad ties. This was the scene in 1953, shortly after the plant caught fire. Unfortunate as the loss was, the plant would have eventually been either closed or remodeled due to environmental concerns. (Courtesy of fire chief Robert Lee Simpkins.)

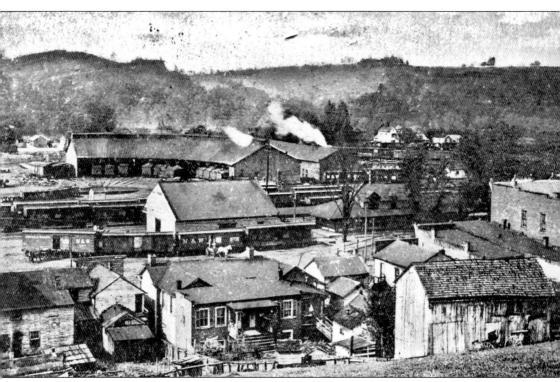
By the time this photograph was taken in the late 19th century, Radford was already a major stop on the Norfolk and Western line connecting Lynchburg to Bristol. However, the majority of the structures on Main Street in the east end of town were still of wood construction. (Courtesy of Mayor Thomas L. Starnes.)

Three
INDUSTRY

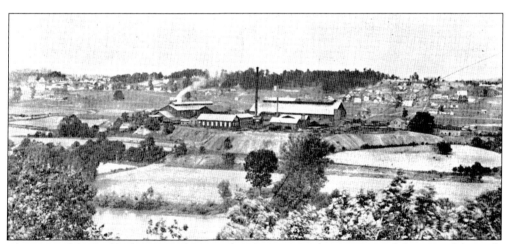

This view of the Radford Pipe Works was taken from across the river around the start of the 20th century. The plant was built in 1892 and has since changed hands several times over the years. Cast-iron pipe and fittings of all shapes and sizes were manufactured here, at the first plant of its type in the South. (Courtesy of the Harvey/Ingles Archives.)

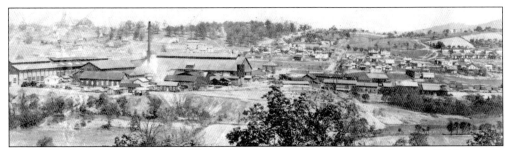

This 1932 photograph of the Lynchburg Foundry at Radford was taken from a hillside on the Pulaski side of the river. At the time, the foundry was a vital economic factor in Radford. It boasted one of the most modern and best-equipped facilities of its type in the country, an ideal location, and good working conditions. (Courtesy of the *Radford News Journal*.)

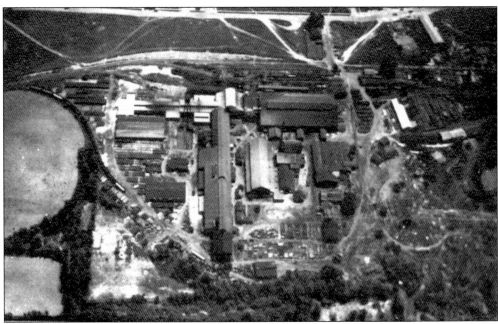

The Lynchburg Foundry is seen in this aerial view, taken in the immediate post–World War II era. Also called "the Pipe Company," the foundry employed around 700 to 800 people in the late 1940s and early 1950s. (Courtesy of the *Radford News Journal*.)

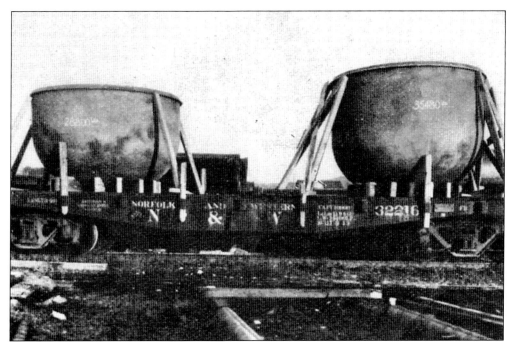

The foundry manufactured caustic pots for use in the chemical industry. Here two caustic pots have been loaded onto a Norfolk and Western flatcar for delivery. The pot on the right was the largest single casting ever made at the foundry at the time of this 1932 photograph. (Courtesy of the *Radford News Journal*.)

A special casting facility at the foundry focused on manufacturing custom-made parts and fittings for business, industrial, and municipal projects. This unique casting was produced in the special foundry during the early 1930s. (Courtesy of the *Radford News Journal*.)

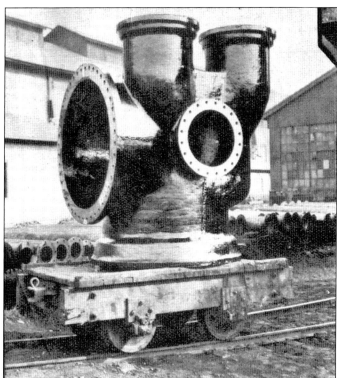

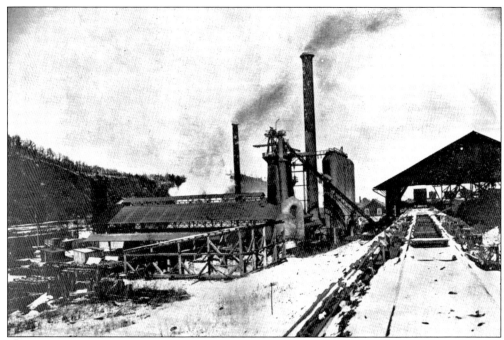
This wintertime view of the Virginia Iron Coal and Coke Company's furnace at Radford was taken around the beginning of the 20th century. This foundry has gone by many names over the years, including the Radford Foundry, the Lynchburg Foundry, the Radford Plant, the Radford Pipe Works, and currently Intermet. (Courtesy of the Harvey/Ingles Archives.)

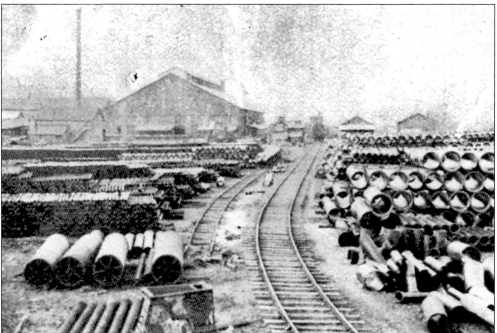
The foundry's pipe yard is pictured in the early 1930s. This illustration represents just a sampling of the types and varieties of iron pipe that was made at the foundry during the early 20th century. (Courtesy of the *Radford News Journal*.)

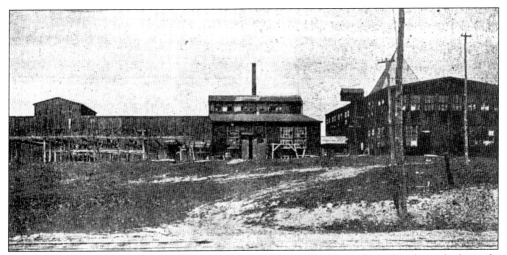

The Radford-Portsmouth Veneer Company operated in Radford from the 1890s through the early 1900s. The plant manufactured oak and poplar veneers for phonographs, pianos, and interior trim. The facility spanned about 35,000 square feet of space and employed around 35 workers. (Courtesy of the Harvey/Ingles Archives.)

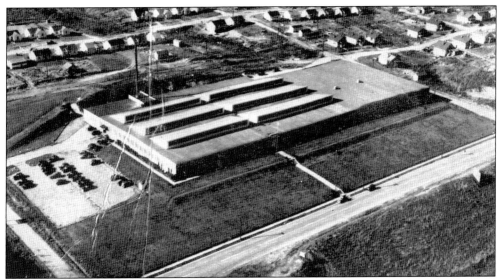

This late-1940s aerial view shows the Radford Weaving Company and some of the surrounding homes in the east end of Radford. The weaving plant, a part of Burlington Industries, was unfortunately closed because of downsizing and foreign competition in the 1980s. (Courtesy of the *Radford News Journal*.)

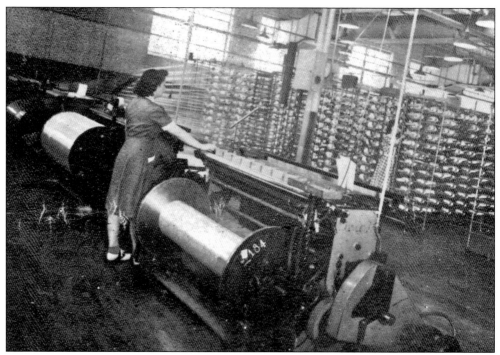
Women process yarn at a Radford Weaving Company workstation in preparation for weaving in the 1940s. (Courtesy of the *Radford News Journal*.)

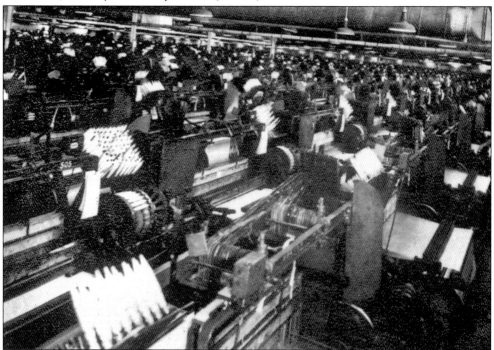
The manufacturing process of the Radford Weaving Company is depicted here in the 1940s. Here the yarn is being woven onto looms. The plant produced satins and taffetas for lingerie. (Courtesy of the *Radford News Journal*.)

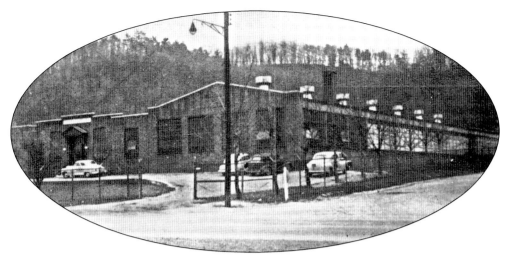

The Radford Knitting Mills plant, pictured in this 1940s image, manufactured fine-gauge ladies' hosiery and employed over 100 people. (Courtesy of the *Radford News Journal*.)

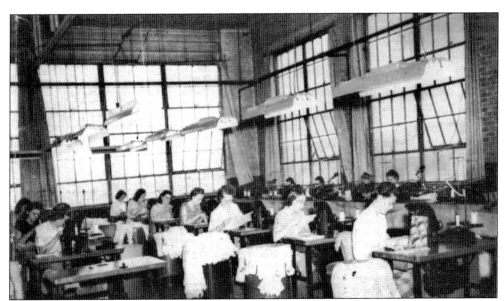

Shown here is the knitting department of the Radford Knitting Mills. At the time of this late-1940s image, the factory used the most up-to-date machinery and modern florescent lighting. (Courtesy of the *Radford News Journal*.)

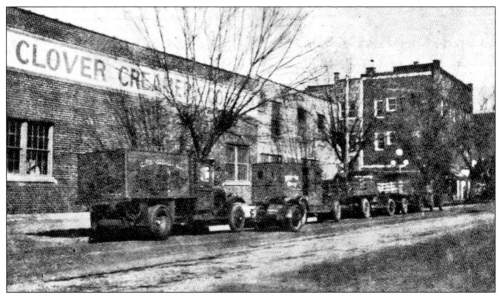
This photograph of the Clover Creamery Company was taken in the late 1920s, when it was one of the largest dairy producers in the state. The Radford facility had nine trucks and employed 15 people. (Courtesy of the *Radford News Journal*.)

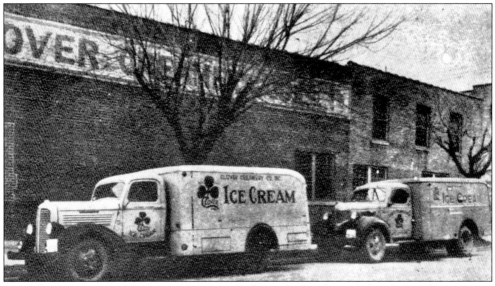
Two Clover Creamery delivery trucks are parked outside the plant in the 1940s. The company was located in the west end in the area that is now Wades Supermarket and parking lot. The creamery distributed milk in Radford and also made ice cream and butter. (Courtesy of the *Radford News Journal*.)

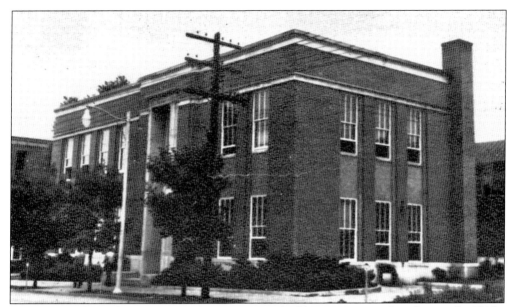

The Chesapeake and Potomac Telephone Company building was new and modern in the 1940s. The structure was built early in the decade to accommodate the increase of telephone calls in the area during the war years. Verizon currently operates from this site. (Courtesy of the *Radford News Journal*.)

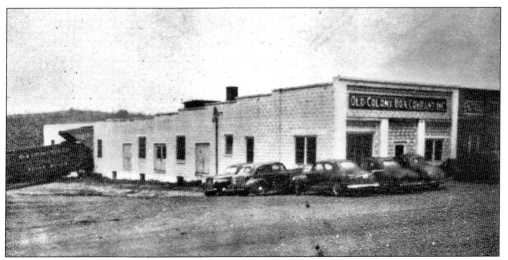

The west end's Old Colony Box Company, pictured in the 1940s, manufactured paper boxes for businesses in the region. This building is now owned by Radford University and is currently used as a storage facility. (Courtesy of the *Radford News Journal*.)

Inland Motor, a division of the Kollmorgen Corporation, was established in Radford in 1958. The company produces motors, drives, DC servomotors, and amplifiers for military and industrial use. Now known as Danaher Motion, the firm still operates as a major employer in the city. (Courtesy of the Radford Heritage Foundation.)

Four
BUSINESS

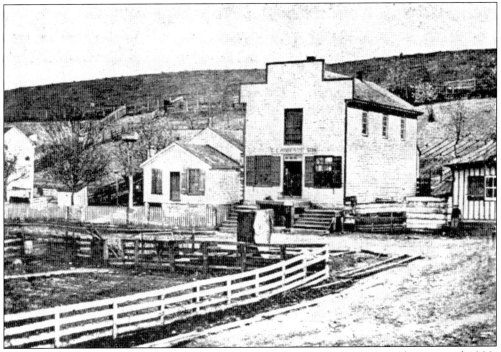

One of Radford's earliest images, this photograph of Roberts Store was taken around 1880. Established by George E. Roberts, the store was located in the east end of town in the area now occupied by the east end business district. (Courtesy of the Radford Heritage Foundation.)

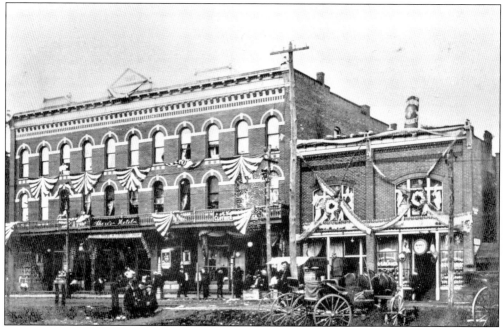

The Hotel Shere is decorated in patriotic garb at the start of the 20th century. The hotel was constructed in 1893, a year after the city's incorporation, and was owned and operated by M. Goldberg. (Courtesy of the Radford Heritage Foundation.)

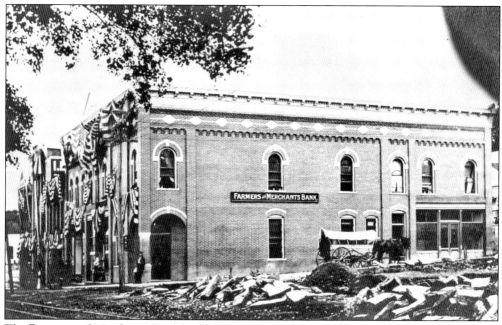

The Farmers and Merchants Bank building, seen around 1900, still stands on the corner of Main Street and Third Avenue and was used as a bank until mid-century. Notice the trolley tracks and wagon. (Courtesy of the Radford Heritage Foundation.)

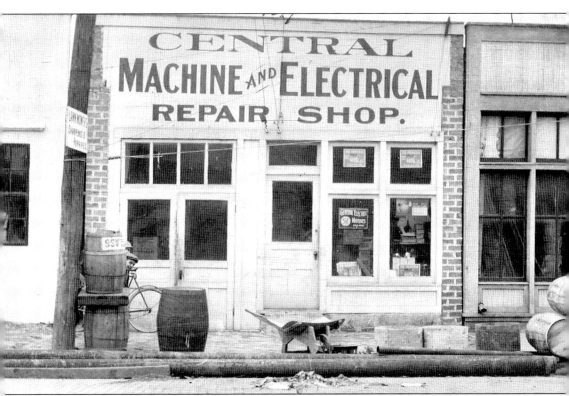

The Central Machine and Electrical Repair Shop was located in the west end at the time of this c. 1906 photograph. A variety of products, ranging from electrical motors to lawn mowers, were serviced by this business. A close look at the image reveals a couple of shy boys peering from behind the glass barrel on the left. (Courtesy of the Ken and Jane Farmer Collection.)

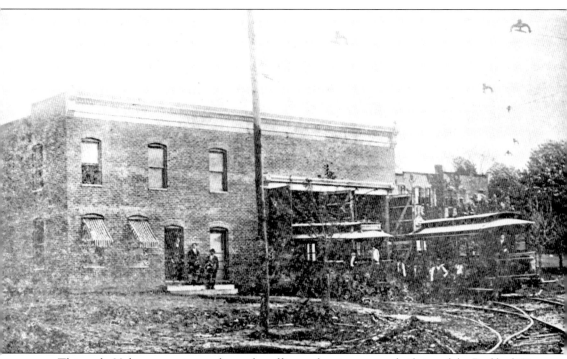

This early-20th-century image shows the office and maintenance facilities of the Radford Water-Power Company, located in the west end. Radford's water, electric power, and trolley transportation were privately owned until 1922, when the utility company was purchased by the city. (Courtesy of the Harvey/Ingles Archives.)

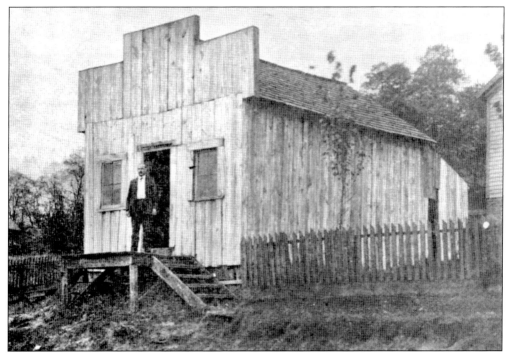

Many entrepreneurs were successful in starting small businesses in Radford at the dawn of the 20th century because of the influx of people moving to the area to work for the railroad, foundry, veneer plant, and other industries that had sprung up. This small grocery store was built by Max Rupe in 1902. (Courtesy of the Radford Heritage Foundation.)

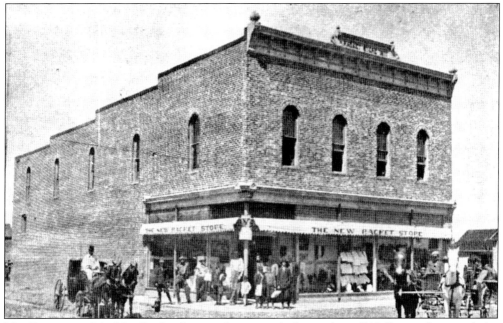

Max Rupe opened the New Racket Store in the west end of town about 1910. During this period, the term *racket store* was used to describe a variety store that sold common household items. It is unlikely that Rupe had any tennis rackets in stock! (Courtesy of the Radford Heritage Foundation.)

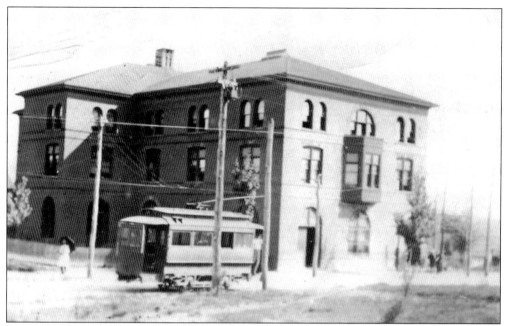

This early-1900s scene provides a good perspective on how simple it was to get around in Radford before the advent of the automobile. The city trolley passes the West End Hotel on its way to the foundry. Cars were rare luxuries at this point; however, the trolley system could move citizens almost anywhere in town. (Courtesy of Mayor Thomas L. Starnes.)

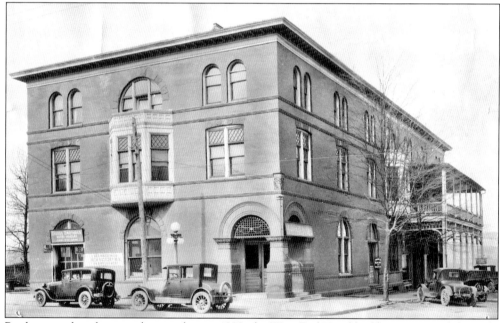

By the time this photograph was taken in 1928, the West End Hotel had been renamed the Delp Hotel. The building also housed a bank and the Dodge Brothers Dealership. The advertisement on the brick wall in the lower left corner is for the Victory Six, a model introduced in 1928. Two years later, the Dodge Brothers motor vehicle company's name was changed to simply Dodge. (Courtesy of William Simpson.)

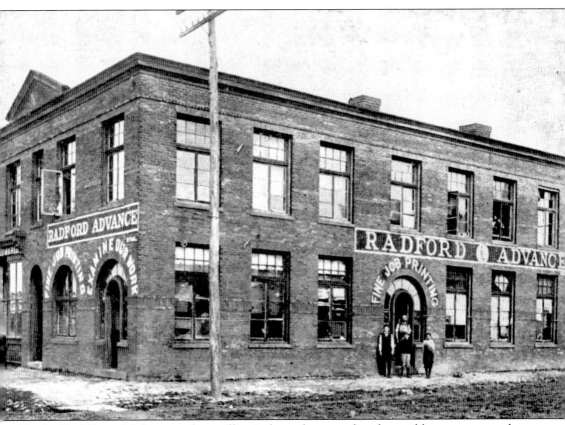

The Radford Record Advance, whose office is shown here, produced a weekly newspaper and served as a publishing and printing company. The newspaper was originally called the *Radford Advance*, then the *Record* in 1912. In 1919, under new ownership the paper became the *Journal*, which was succeeded by the *News Journal* in 1928. The *News Journal* has changed hands several times since 1928, though the name of this local Radford biweekly paper has not been altered. (Courtesy of the Harvey/Ingles Archives.)

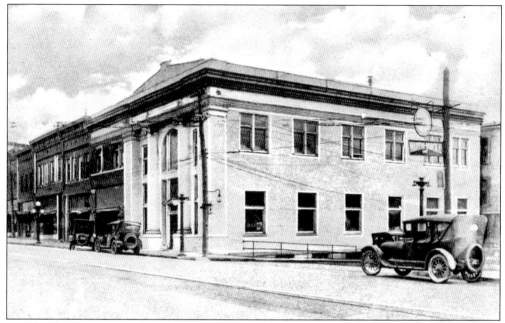

In 1932, the First National Bank of Radford merged with the Farmers and Merchants National Bank of Radford to form the First and Merchants National Bank, one of the largest financial institutions in the area during the mid-1900s. The financial institution is no longer active, and the spot where the building was located is now used for downtown parking. (Courtesy of Mayor Thomas L. Starnes.)

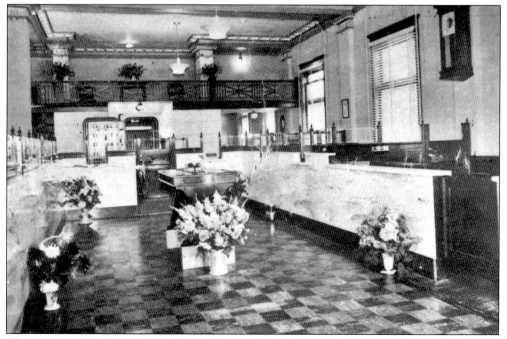

The interior of the First and Merchants National Bank of Radford is pictured in the late 1940s. The bank was one of the major lenders that facilitated the development of the city during this period. (Courtesy of the *Radford News Journal*.)

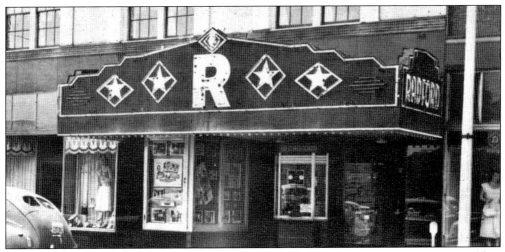

The Radford Theatre, seen in the 1940s, is located in the east end business district and has been in operation for over 70 years. It is one of the only surviving classic one-screen theaters in southwest Virginia. (Courtesy of the *Radford News Journal*.)

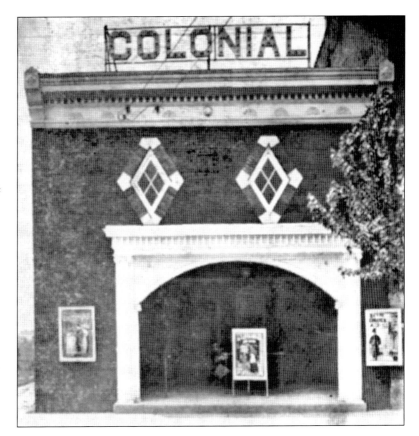

The west end's Colonial Theatre was built for plays and then converted into a moving picture house. The business, later renamed the State Theatre, remained in operation until around 1953. This photograph was taken before 1915. (Courtesy of the Harvey/Ingles Archives.)

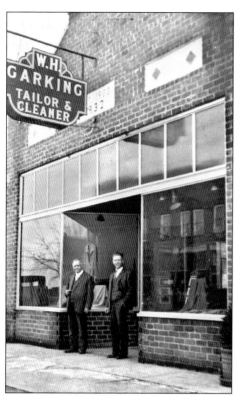

By the time of this 1930s photograph, W. H. Garking (left), shown with son Cragle Garking, had been a tailor in Radford for more than 30 years. This building still stands today as a Smith Barney office. (Courtesy of Bette Wright.)

The interior of W. H. Garking's merchant tailor shop was quite luxurious in the 1930s. Clients could choose from a variety of the latest styles and have the garments custom fitted. The business also offered dry-cleaning and pressing. (Courtesy of Bette Wright.)

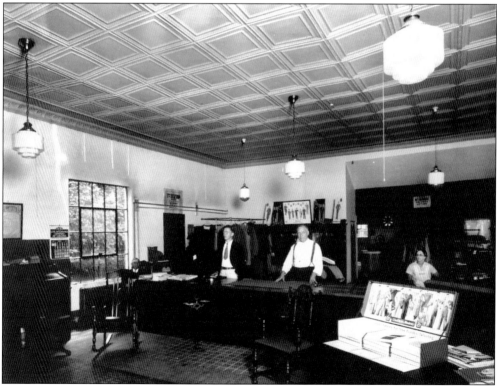

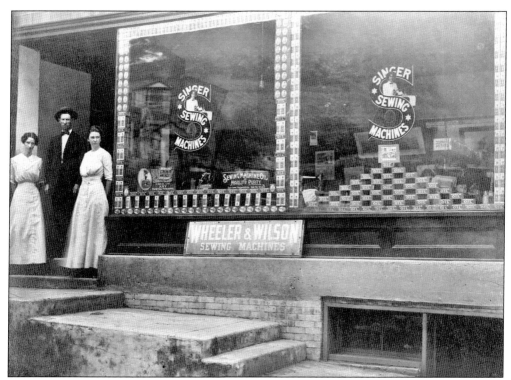

Sewing machines were important home products in the early part of the 20th century, with Singer as the predominant manufacturer of the period. Shown here is a group of unidentified people outside the Wheeler and Wilson Singer dealership in Radford. (Courtesy of the Radford Heritage Foundation.)

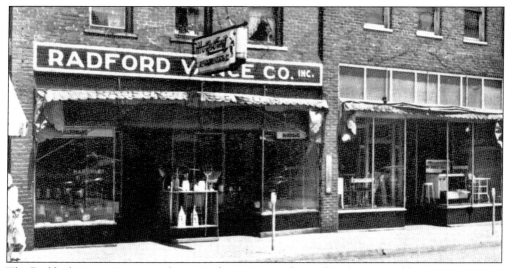

The Radford Vance Company, shown in the 1940s, was located in the east end business district. It was part of a regional chain of hardware stores with locations throughout southwest Virginia. The chain was able to provide excellent service because of its large territory and excellent resources. (Courtesy of the *Radford News Journal*.)

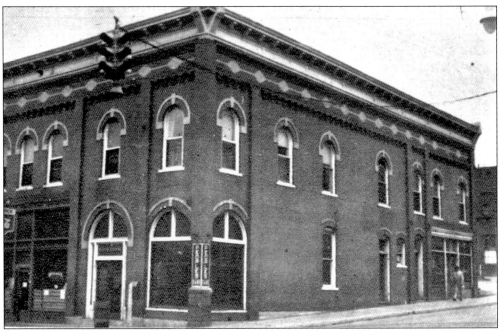

The People's Bank of Radford was conveniently situated in the east end business district, on the corner of Main Street and Third Avenue, at the time of this 1940s view. The bank's slogans at the time were "Growing with Radford" and "Serving a Progressive Community." (Courtesy of the *Radford News Journal*.)

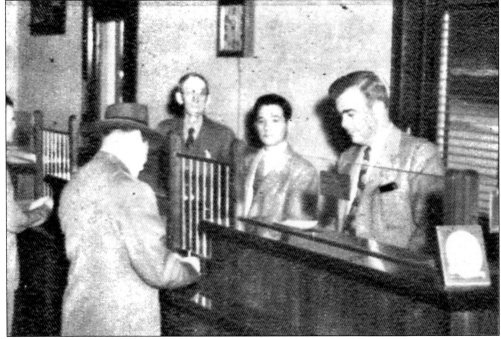

The interior of the People's Bank is pictured in the 1940s. J. H. Epperly served as president and John B. Spiers as vice president during the immediate post–World War II era. (Courtesy of the *Radford News Journal*.)

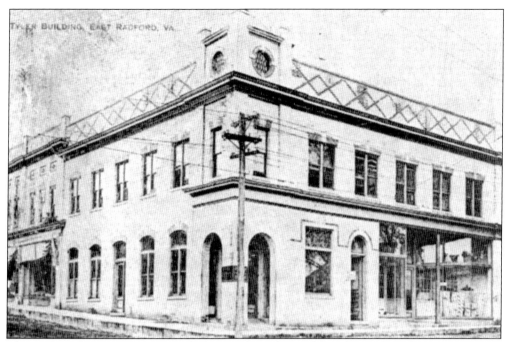

This early-20th-century photograph depicts the Tyler Building, located on the corner of East Main Street and Third Avenue. The Radford Furniture Company was housed here for many years. This structure was eventually torn down, and a branch of the BB&T bank now occupies this site. (Courtesy of the Harvey/Ingles Archives.)

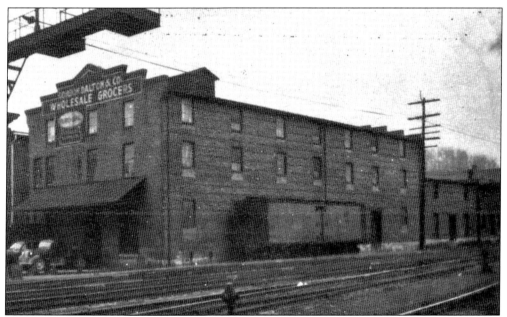

Gordon Dalton and Company wholesale grocer distributed Pleasing Brand products. The firm also sold paints and varnishes. Seen in this 1940s rear view, the company was conveniently located by the railroad tracks and received shipments by rail. (Courtesy of the *Radford News Journal*.)

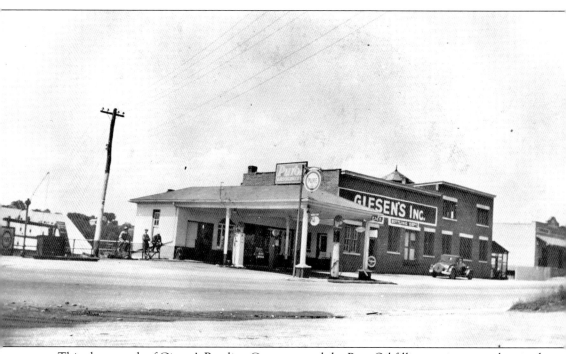

This photograph of Giesen's Bottling Company and the Pure Oil filling station was taken in the 1930s. The bottling company produced soda pop and also served as a warehouse for the soft drinks. These businesses were located on Main Street just east of the Radford Ice Company, near the area that is now the entrance to Bisset Park. (Courtesy of the Radford Heritage Foundation.)

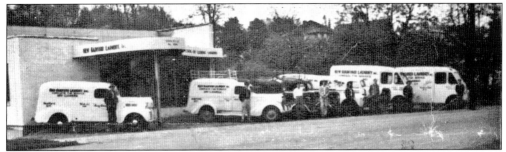

The New Radford Laundry is shown in the 1940s, when the facility was actually new. The company, in operation today at the same site, is still owned by the Cook family. Now known as Cook's Clean Center, the west end business is easily recognizable, less the fleet of trucks that appears in this photograph. (Courtesy of the *Radford News Journal*.)

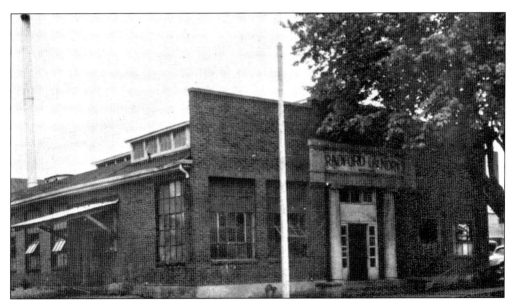

The Radford Laundry plant stood just across the street from the dry-cleaning plant in the west end. This building still stands, though it is not currently being used as a laundry facility. The business was new at the time this photograph was taken in the 1940s. W. L. Cook served as president and general manager. (Courtesy of the *Radford News Journal*.)

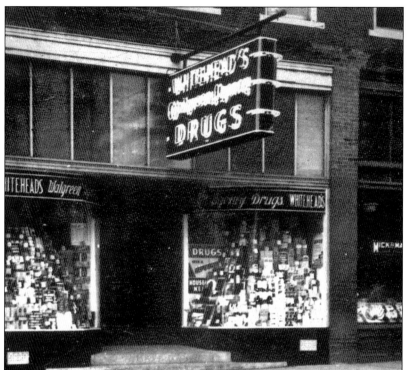

Whitehead's Pharmacy was a fixture in the east end business district for years. This exterior shot of the popular drugstore was taken in the immediate post–World War II era. (Courtesy of the *Radford News Journal*.)

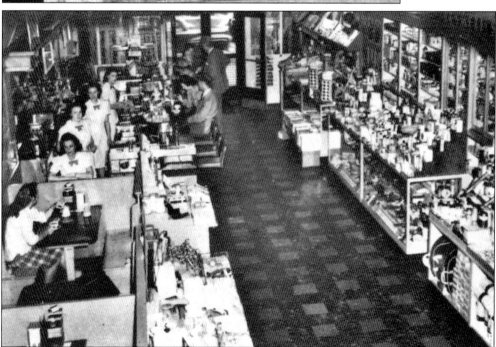

Naturally, Whitehead's Pharmacy had a soda fountain, as was common in drugstores during the early to mid-1900s. This fashionable soda fountain, which was known for its excellent service, also offered soft drinks, sandwiches, and other fare. Four uniformed attendants are shown in this 1940s image. (Courtesy of the *Radford News Journal*.)

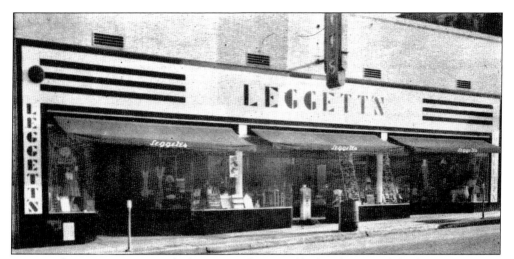

Leggett's department store was the largest retailer in Radford at the time of this late-1940s image and an anchor store in the east end business district. The exterior was designed in the art deco style popular during the period. (Courtesy of the *Radford News Journal*.)

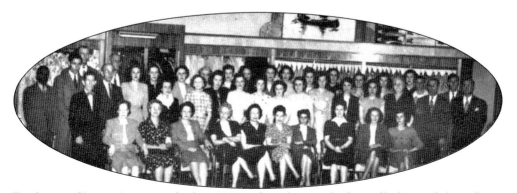

Employees of Leggett's pose in the late 1940s, when the store had a staff of 44 and three floors of retail space. It was promoted as "Southwest Virginia's Leading Shopping Center." (Courtesy of the *Radford News Journal*.)

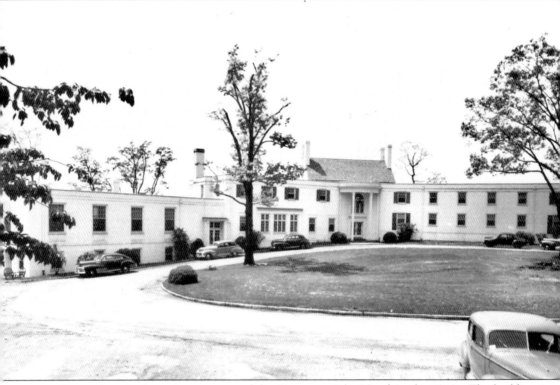

Shown here is the main entrance of the Governor Tyler Hotel in the 1940s. The building is memorable and impressive in its placement high on a bluff overlooking the New River. (Courtesy of Mayor Thomas L. Starnes.)

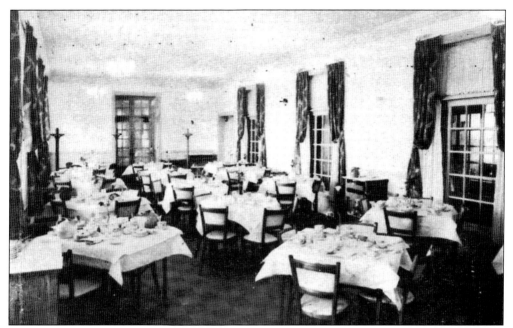

The Governor Tyler Hotel dining room, pictured in the late 1940s, had a reputation for excellent food and service. The hotel also included banquet facilities and ballrooms. Countless wedding receptions and other formal occasions took place at the Governor Tyler over the years, and many Radford citizens still hold fond memories of events held there. (Courtesy of the *Radford News Journal*.)

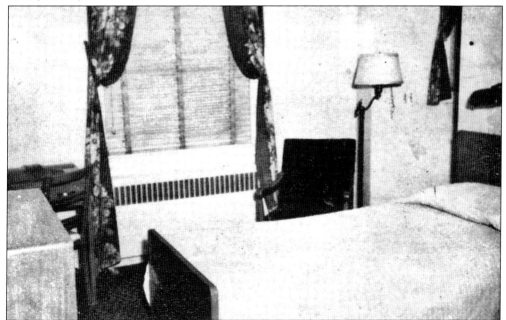

A Governor Tyler Hotel bedroom is seen during the early years of the inn's operation. The hotel originally consisted of 40 guestrooms; more were added with the acquisition of another building on Downey Street. The added rooms now serve as one-room apartments primarily used by Radford University students. (Courtesy of the *Radford News Journal*.)

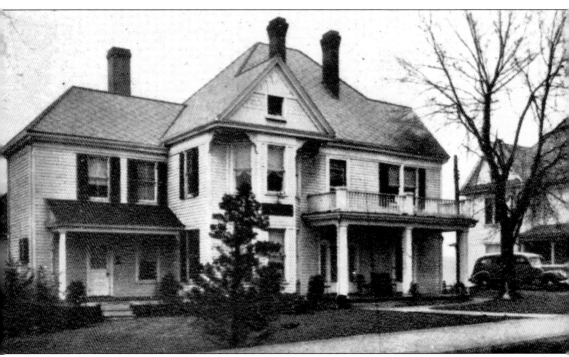

The DeVilbiss Funeral Home was located on Grove Avenue in the 1940s. At this time, the chapel had a seating capacity of 150 and a private exit. The business had been previously owned by Richardson and Perfater, licensed undertakers and embalmers. (Courtesy of the *Radford News Journal*.)

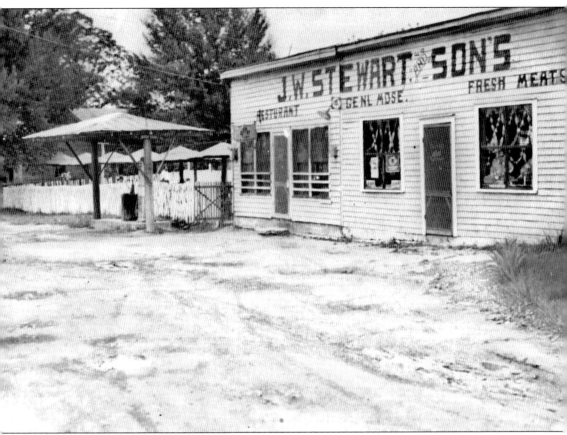

J. W. Stewart and Son's store and restaurant was a fixture on Rock Road for many years. The establishment stood just east of the Zion Hill Baptist Church. J. W. Stewart, beloved among community members, also worked for the foundry. After retiring, he operated this store full-time until his unfortunate passing in the early 1950s. (Courtesy of Sarah Carter.)

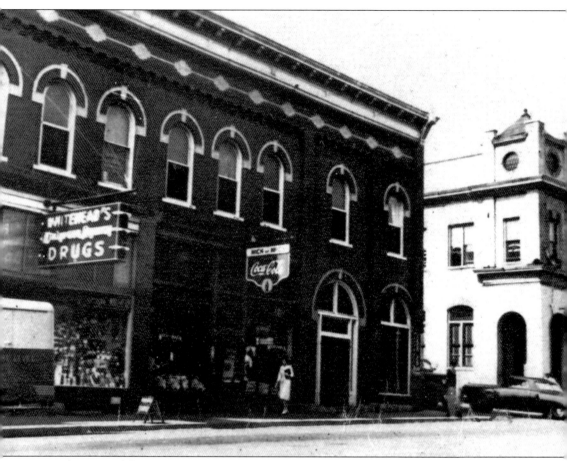

This view of the east end business district in the 1940s depicts the following from left to right: Whitehead's Pharmacy, the Mick-or-Mack Grocery, the People's Bank of Radford, and the Tyler Building. (Courtesy of the *Radford News Journal*.)

Five
EDUCATION

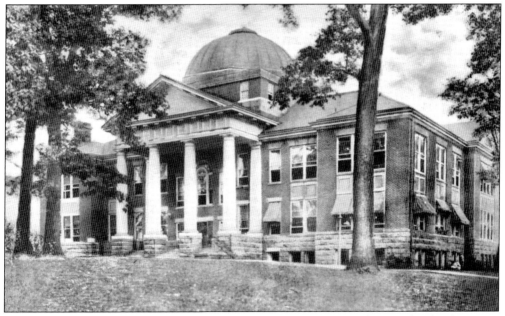

The old administration building was the first structure on the Radford Normal School campus. Dedicated in 1913, it was renamed Founder's Hall in the 1950s. The building, famous for its ornate features, was demolished in the 1960s to make room for Muse Hall; many alumni were dismayed by its unfortunate demise. (Courtesy of the Radford Heritage Foundation.)

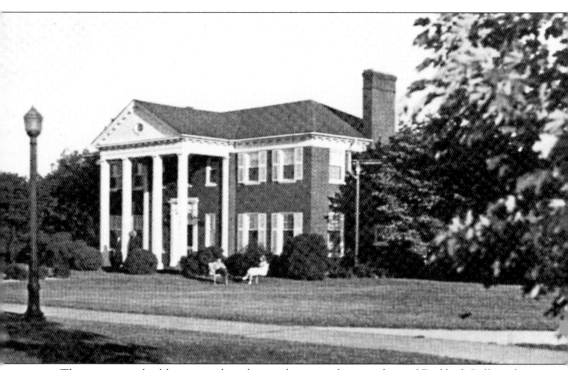

This attractive building served as the residence to the president of Radford College from its completion in 1939 until 1972, when it was torn down to allow for construction of Heth Hall. Dr. David W. Peters became president on January 1, 1938, and moved into the newly constructed building during the last week of February 1939. (Courtesy of the Radford Heritage Foundation.)

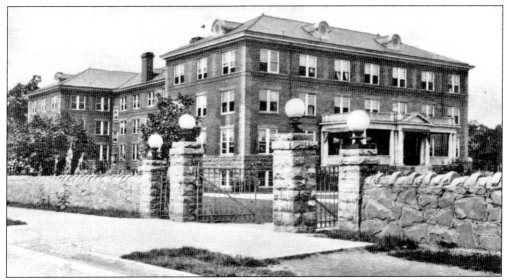

Tyler Hall was one of the original buildings on the campus of Radford Normal School. Erected in 1916, it saw renovations in the 1960s and 1990s and is in use today as a dormitory. The structure was named after one of Radford's most notable citizens, Virginia governor James Hoge Tyler. (Courtesy of the Radford Heritage Foundation.)

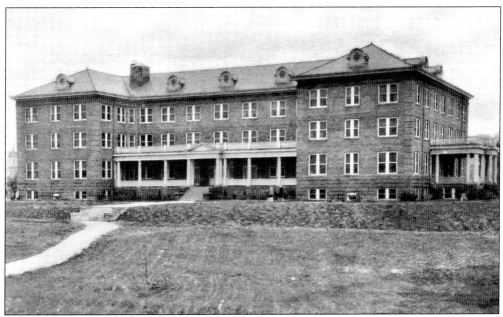

Madame Russell Hall was constructed in 1927 to serve as a dormitory. The building was named after Madame Elizabeth Russell, the sister of Patrick Henry and a prominent citizen in southwest Virginia during the early 19th century. It was totally renovated in 1987 and is still in use by Radford University. (Courtesy of Mayor Thomas L. Starnes.)

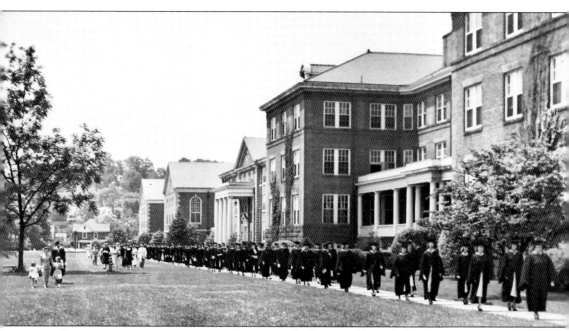
Commencement ceremonies are always grand affairs, and June 1, 1952, was no exception. The graduates proudly marched past the buildings that had been such an integral part of their lives over the past four years. (Courtesy of the Radford University Archives.)

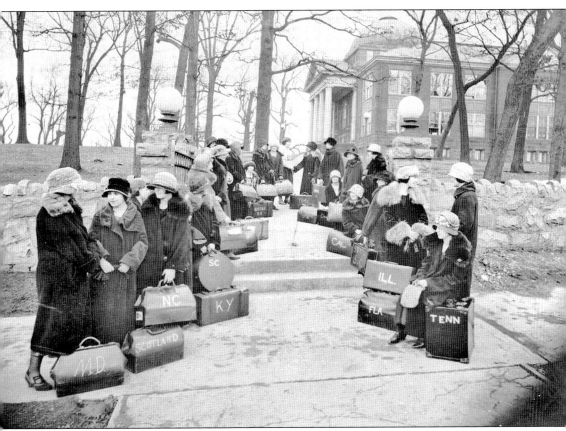
Radford College students wait patiently off Tyler Avenue (with Founder's Hall in the background), ready to head home at the end of the fall semester. The young ladies' hats and coats appear to be 1920s fashions. (Courtesy of the Radford University Archives.)

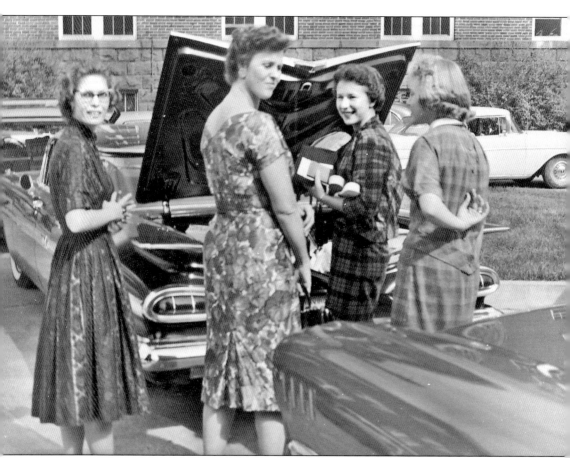

Every fall, a scene similar to this one plays out on the campus of the university, as students arrive in Radford for another year in college. However, in the early 1960s when this photograph was taken, the students were probably less apt to be embarrassed by having their mothers come along to help them get situated! (Courtesy of the Radford University Archives.)

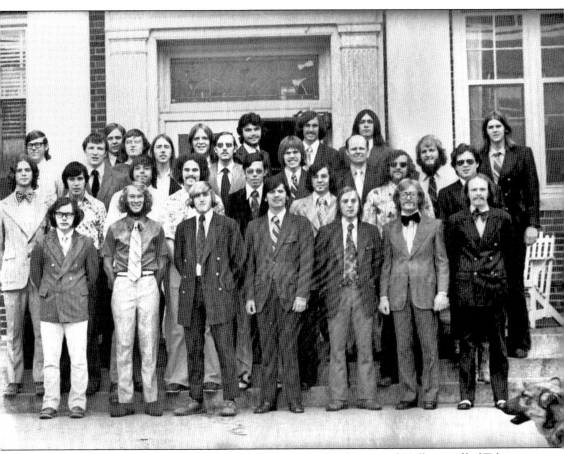

The first men to graduate from Radford College pose in front of Norwood Hall, just off of Tyler Avenue, in May 1973. After this photograph was taken, a banquet was held in their honor. Radford College had been an all-female school for over 60 years, and the acceptance of males dramatically changed policies, curriculum, and the public's view of the institution. (Courtesy of the Radford University Archives.)

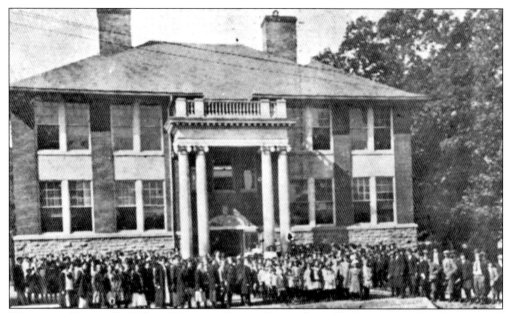

This view of the Radford High School faculty, student body, and building, was taken before 1915. In 1929, when a new high school was constructed, this structure was then used as an elementary school. This building, still standing on the corner of Third Avenue and Downey Street, now serves the Radford City Health Department. (Courtesy of the Radford Heritage Foundation.)

Kuhn Barnett Elementary School was located on Fourth and Pendleton Streets in Radford's west end. Built in 1924, it was named for Kuhn Barnett, who was superintendent of Radford schools from 1920 to 1937. The building remains, though no longer in use as a school. (Courtesy of the Radford Heritage Foundation.)

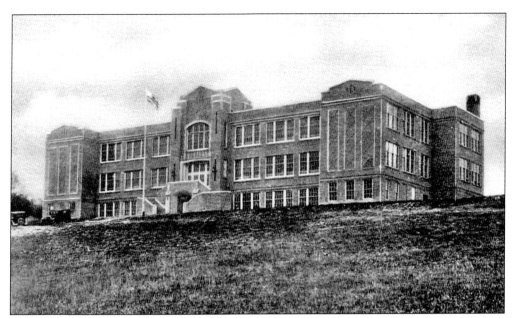

The second Radford High School building was constructed in 1928 and burned to the ground in 1970. The school stood in a central location between the east and west ends in an effort to unite the city. The land for the site once belonged to the city's founder, John Blair Radford. The present-day Radford High School building occupies the same ground. (Courtesy of Mayor Thomas L. Starnes.)

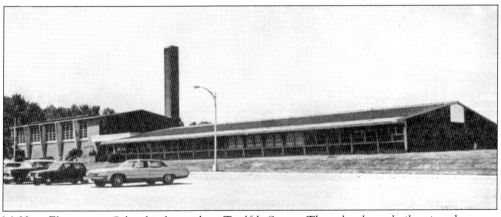

McHarg Elementary School is located on Twelfth Street. The school was built using the same blueprints as the Belle Heth Elementary School, just off Second Avenue. Both schools were completed in 1957 and are still in use, although they have seen renovations and additions over the years. (Courtesy of the Radford Heritage Foundation.)

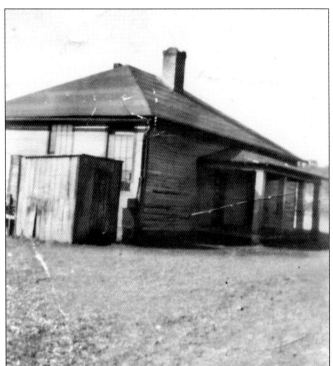

The first school for African Americans in Radford, seen here, was constructed in 1912 on Hornbarger Hill near the current location of Belle Heth Elementary. The small building on the left was for storing wood and coal for heating. Another African American school was completed in the west end near Rock Road in 1920. (Courtesy of Sarah Carter.)

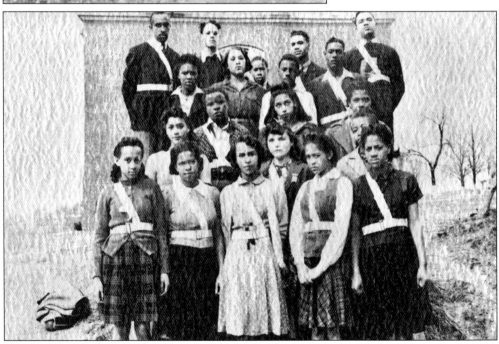

During the era of segregation, there was no high school in Radford for African Americans; instead, they had to travel 10 miles to the Christiansburg Institute to further their education. Pictured in this 1942 photograph are the Christiansburg student officers. The school was modeled after the Tuskegee Institute in Alabama. (Courtesy of the Christiansburg Institute Collection, Virginia Polytechnic Institute and State University.)

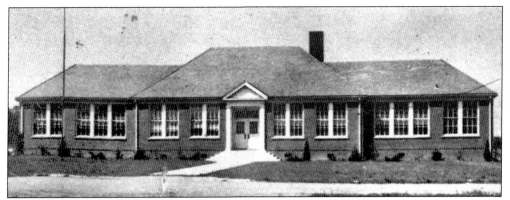
The Fred Wygal School was an African American elementary school functioning from 1943 to 1966. In 1967, when the Radford Public Schools were desegregated, this building became the administration offices for the school system. It is still in use on Wadsworth Street. (Courtesy of the *Radford News Journal*.)

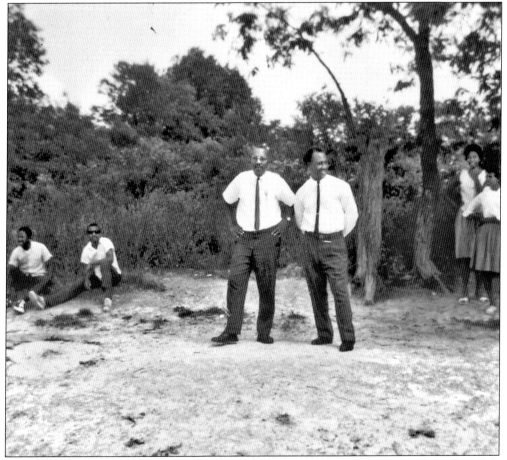
William J. Manning (left) was appointed principal of the Fred Wygal Elementary School in 1963 with George Mills as assistant principal. The school was closed at the end of the 1965–1966 school year, and the students were integrated into the other elementary schools in the city. (Courtesy of Sarah Carter.)

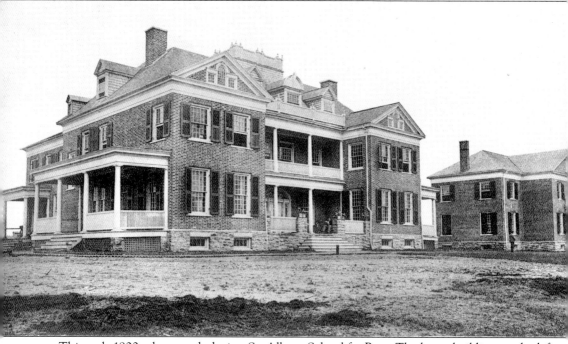

This early-1900s photograph depicts St. Albans School for Boys. The larger building on the left served as a dormitory accommodating around 50 students. In 1916, the school closed because of financial difficulties. The compound was then converted into St. Albans Sanatorium, a psychiatric clinic. The land and facilities are now a part of Radford University. (Courtesy of the *Radford News Journal*.)

Six
Buildings, Churches, and Homes

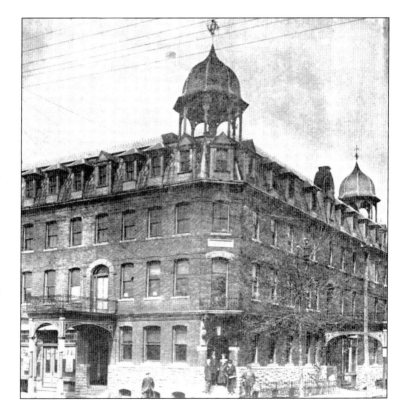

The old Radford Courthouse was originally constructed as a school by Confederate general Gabriel Colvin Wharton. For part of the 19th century, the building served as a hotel but has since been in use by the City of Radford for over 100 years. The facility is now the Radford Police Department headquarters. (Courtesy of the Harvey/Ingles Archives.)

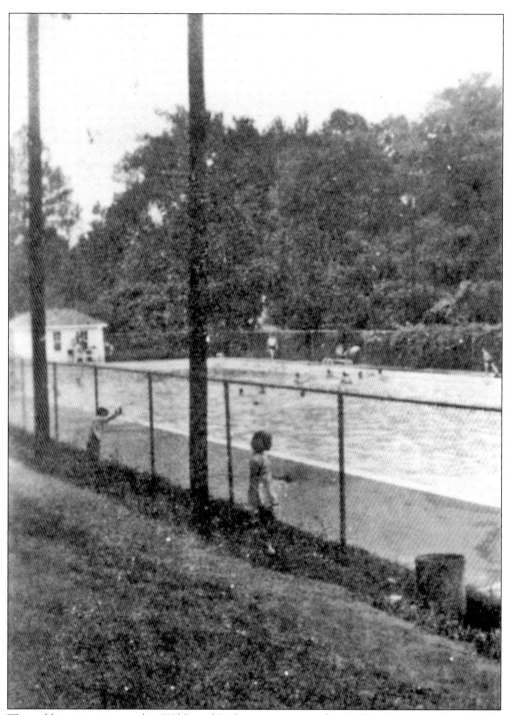

The public swimming pool at Wildwood Park was constructed in 1929 and saw use through the early 1970s. Along with the pool, the location boasted a picnic area, playground, and pavilion. The pool was filled in and the park closed in the 1970s, when Bisset Park was completed. Wildwood has recently been revitalized as an area for hiking, bicycling, and nature study. (Courtesy of the Radford Heritage Foundation.)

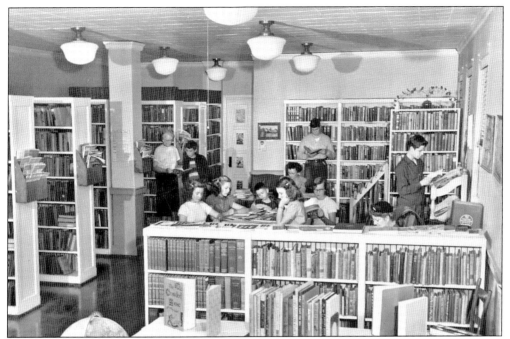

The Radford Public Library initially consisted of a 1,700-square-foot room inside the Radford Recreation Building. This photograph of the facilities was taken in 1953. The space in the Recreation Center served as the city's only public library from 1941 until 1980, when a much-needed separate building was finally completed. (Courtesy of the Radford Public Library.)

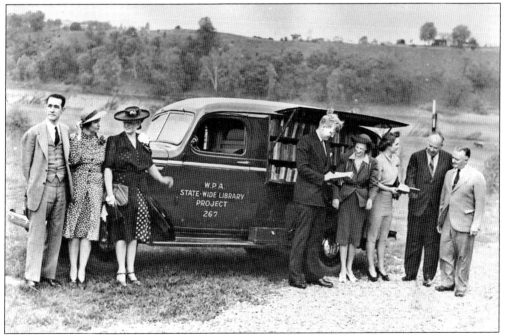

In addition to constructing the Radford Recreation Center that housed the Radford Public Library, the WPA allocated this bookmobile to the library in 1941. It traveled through Radford and the surrounding areas. (Courtesy of the Radford Public Library.)

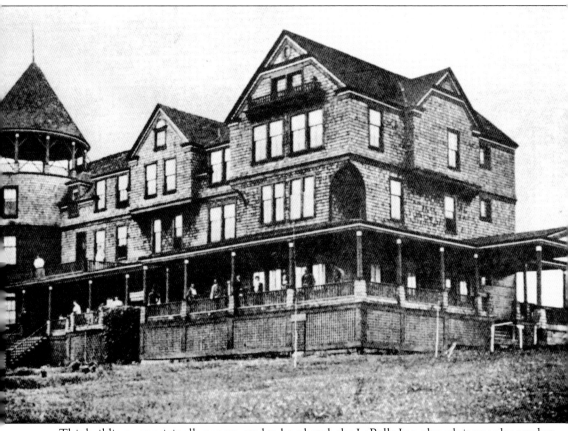

This building was originally constructed to be a hotel, the LaBelle Inn, though it was also used as the Valley View Hospital to treat injured railroad construction workers. When Radford Normal School was established in 1910, the structure became a makeshift dormitory. (Courtesy of the Radford Heritage Foundation.)

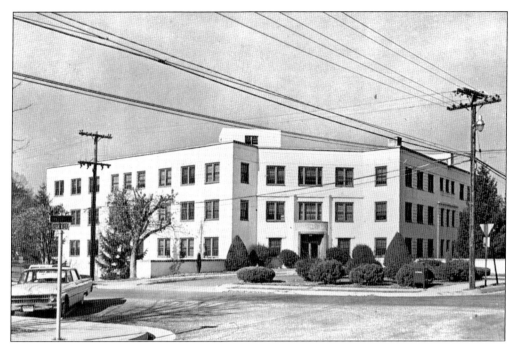

The Radford Community Hospital was built by the Federal Works Agency under the Lanham Act and opened on September 18, 1943. Standing at the corner of Eighth and Randolph Streets, the U-shaped building was four stories high and constructed of brick that was painted white. It was razed in the 1990s when a new hospital was built near Interstate 81. (Courtesy of the Radford Heritage Foundation.)

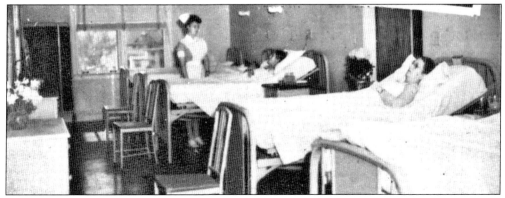

An old Radford Community Hospital ward is pictured during the 1940s. The facility had a bed capacity of 68 at the time. (Courtesy of the *Radford News Journal*.)

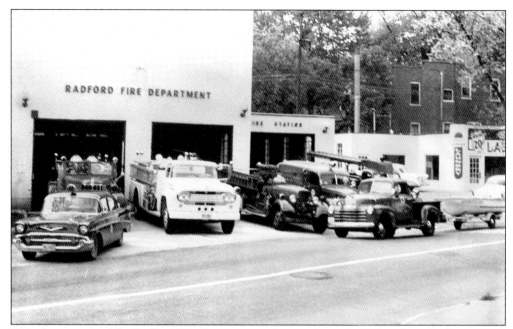

This photograph of the Radford Fire Station was taken in the early 1960s, when the department was located at the intersection of Arlington and Main Streets in the east end. The building formerly housed the maintenance and storage facilities for the Radford Trolley System. (Courtesy of fire chief Robert Lee Simpkins.)

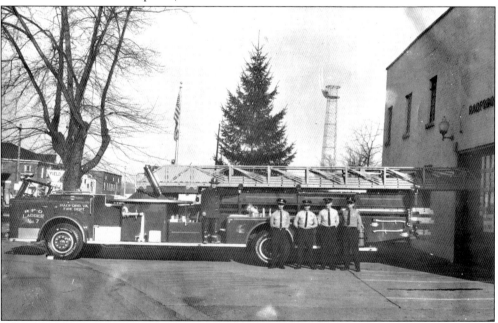

The Radford Fire Department had just acquired this ladder truck in 1967, when this view was taken at the old fire station at Arlington and Main Streets. The station burned down while the department was fighting another fire in town. After the destruction of this building, the fire department moved to its current location at 1500 Wadsworth Street. (Courtesy of fire chief Robert Lee Simpkins.)

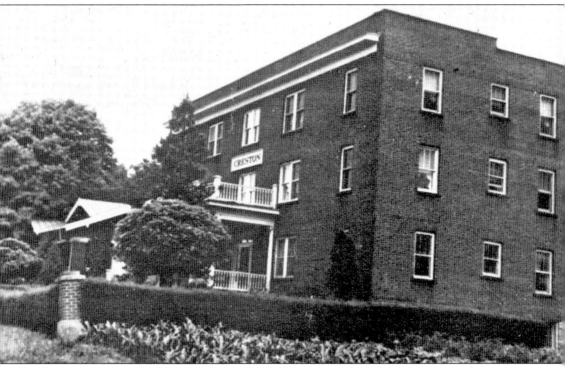

The Creston apartment building, shown in the 1940s, is situated on Second Street in the west end. The building is still in use as apartment housing and has changed very little over the years. (Courtesy of the *Radford News Journal*.)

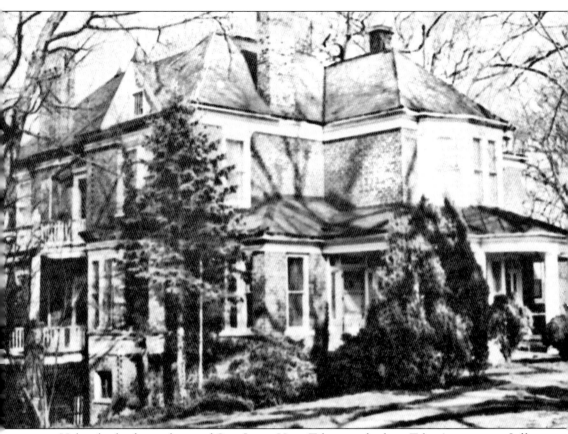

Halwyck, the former home of Gov. James Hoge Tyler, stands along Tyler Avenue near Jefferson Street, adjacent to the Radford University campus. The 1890s residence was listed on the National Register of Historic Places in 1997. (Courtesy of the Radford Heritage Foundation.)

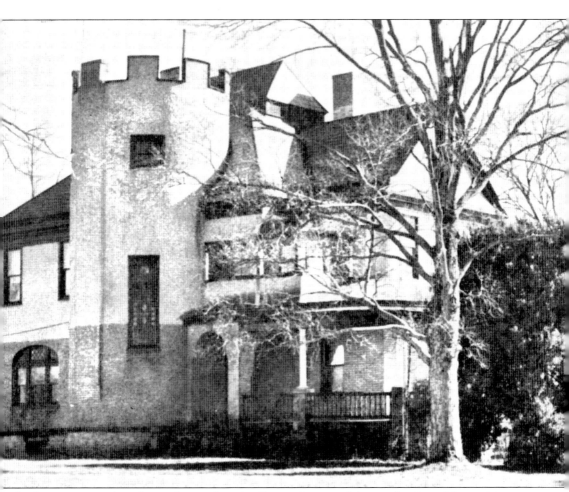

La Riviere is a striking home designed in the Queen Anne architectural style and located just off Ingles Street in the west end. The house was constructed in 1892 for William "Captain Billy" Ingles, a civic-minded gentleman who was also a civil engineer and entrepreneur in Radford. (Courtesy of the Radford Heritage Foundation.)

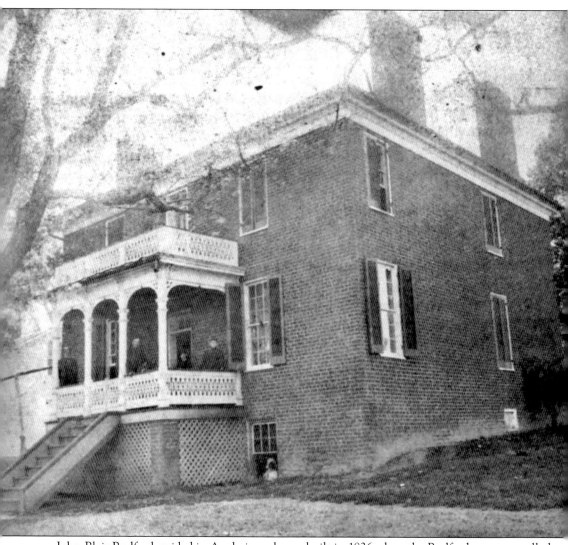

John Blair Radford resided in Arnheim, a home built in 1836 when the Radford area was called Lovely Mount. It was damaged by a Union artillery barrage during the Civil War and later converted into the home economics annex for Radford High School. This photograph was taken in the 1890s. (Courtesy of the Radford Heritage Foundation.)

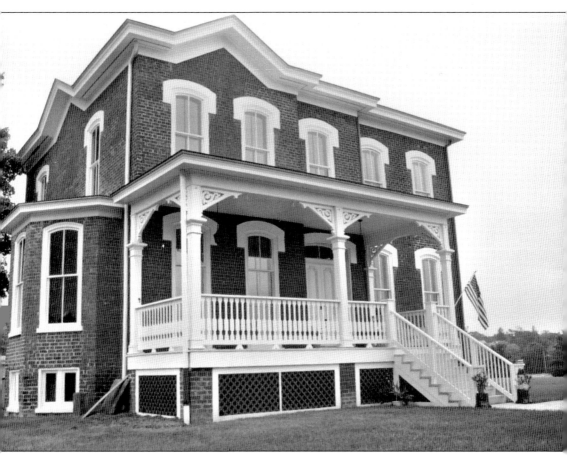

Glencoe Museum originally served as the home of Brig. Gen. Gabriel Colvin Wharton. General Wharton settled in Radford following the Civil War and had the home constructed in 1870 for the cost of $3,000. It was named after a village in Scotland. (Courtesy of the Radford Heritage Foundation.)

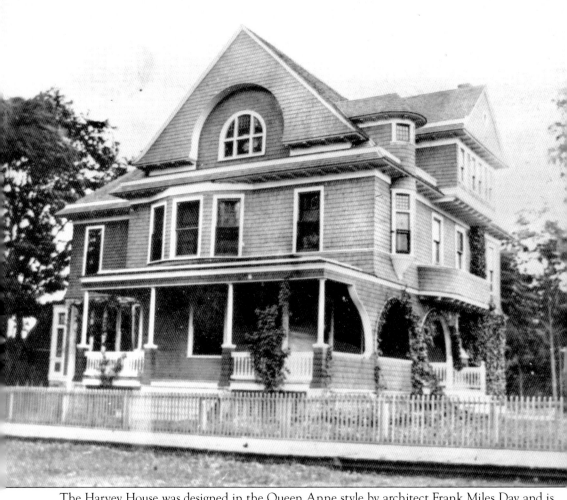

The Harvey House was designed in the Queen Anne style by architect Frank Miles Day and is now listed on the National Register of Historic Places. The home was originally built in 1891 for J. K Dimmock, who started the foundry in Radford. It was purchased by Lewis and Betty Harvey in 1906 and is still owned by their descendants. This 1907 photograph also shows the boardwalk running along Eighth Street. (Courtesy of the Harvey/Ingles Archives.)

Sarah Carter took this photograph of her cousin Jackie Jones in May 1965. In the background is the Masonic lodge located on Rock Road. The lodge hall was totally destroyed by a tornado that touched down in the Rock Road area in 1987. (Courtesy of Sarah Carter.)

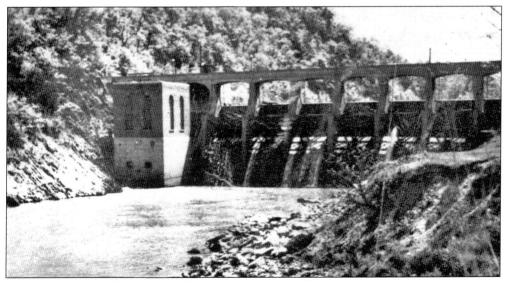

Completed in 1933, the city-owned Little River Dam is still in use today as a hydroelectric plant. The dam produces a portion of the power for the city's electrical needs. (Courtesy of the *Radford News Journal*.)

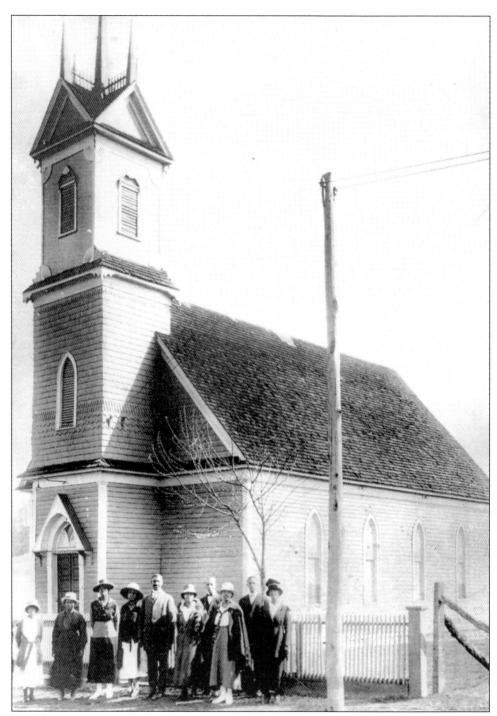

Shown here is the First Baptist Church on Fairfax Street that was purchased by a group African American parishioners in 1897. It was originally built in 1891 by a Lutheran congregation. In 1961, Radford College bought the building in order to provide more space for its students. The congregation already had plans for a new structure on West Street. The new First Baptist Church building on West Street was dedicated on January 21, 1962. (Courtesy of Sarah Carter.)

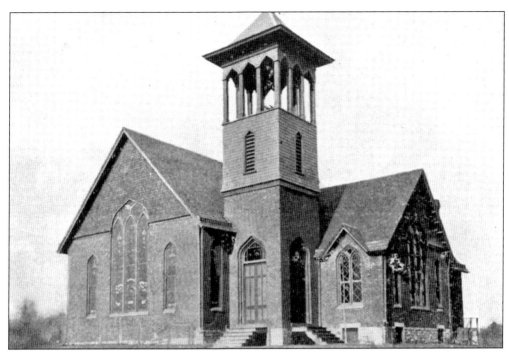

Shown is the Radford Presbyterian Church that was completed on Fourth Avenue in 1894. Delays during its construction dismayed many Radford Presbyterians, who then organized and built Tyler Memorial Presbyterian Church on Tyler Avenue. In 1968, the Tyler Avenue congregation reunited with the Fourth Street congregation to become the Presbyterian Church of Radford. (Courtesy of the Harvey/Ingles Archives.)

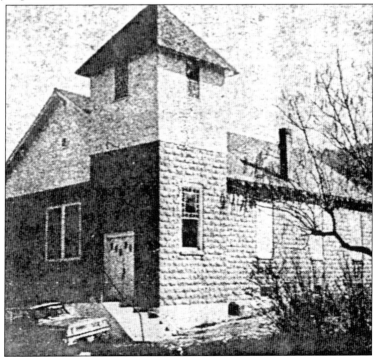

The Zion Hill Baptist Church was constructed on Rock Road in 1928. Before the erection of this building, the congregation met at the First Baptist Church on Fairfax Street in Radford's east end. In 1964, an educational and social annex was added to the structure. (Courtesy of Sarah Carter.)

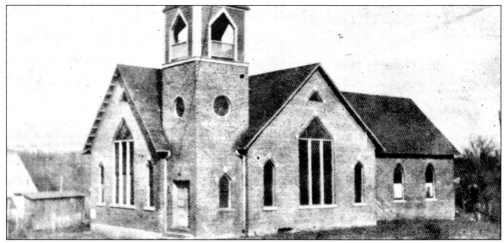

This church was built on the corner of Third and Wirt Streets in 1894, the Bourne Memorial Methodist Episcopal Church structure was then moved to the corner of Second and Wadsworth Streets in 1913. It was also renamed the Radford Methodist Church at the time of the move. In 1943, the church was officially renamed Central Methodist. In 1955, a new church was built on the corner of Wadsworth and Eighth Streets. This building remains today on the corner of Second and Wadsworth. (Courtesy of the *Radford News Journal*.)

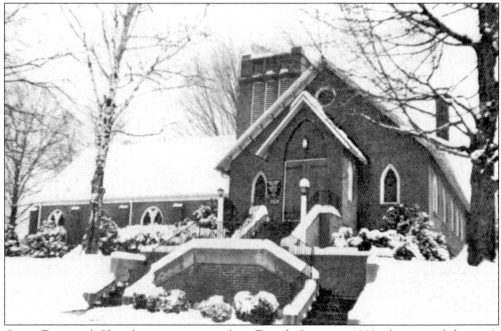

Grace Episcopal Church was constructed on Fourth Street in 1892, the year of the city's incorporation. The chapel and grounds have seen several additions over the years; however, the original chapel is still recognizable in this photograph, taken before 1915. (Courtesy of the Radford Heritage Foundation.)

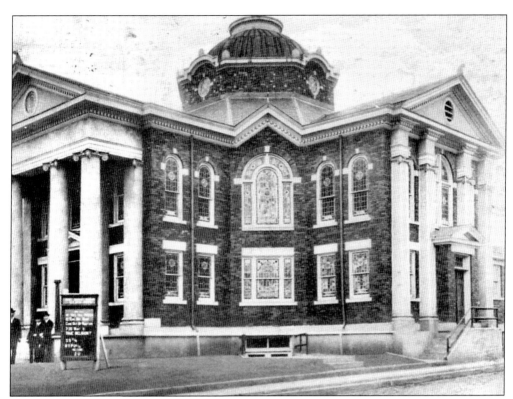

The First Baptist Church at the corner of Third and Downey Streets was completed in 1921 and is still being used by the congregation. Described as a "classic design," the church features a beautiful, round, glass dome. Baptists organized a congregation in Central Depot in 1896 and moved to this site from their church building, located in between Norwood and Pickett Streets. (Courtesy of Mayor Thomas L. Starnes.)

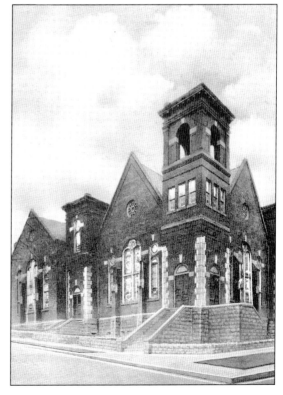

The Grove Avenue Methodist Church was completed in 1914. The congregation moved to a new location on Tyler Avenue in 1975, and some of the materials used in this structure were incorporated into the new church. This beautiful building still stands, though it has been converted to apartments. (Courtesy of Mayor Thomas L. Starnes.)

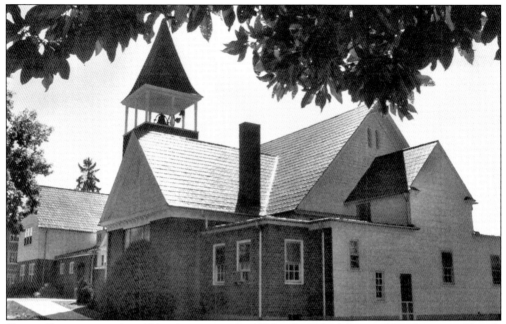

Originally constructed on Tyler Avenue in the 1890s, the Tyler Memorial Presbyterian Church building was moved to its present location on Fairfax Street on the Radford University campus in 1952. The building was used as a campus chapel for many years and, in 1990, converted to academic space. Now known as Fairfax Hall, it is occupied by the university's Department of Philosophy and Religious Studies. (Courtesy of the Radford Heritage Foundation.)

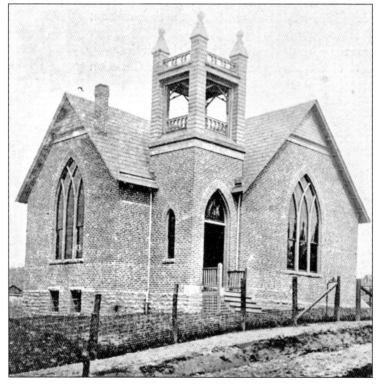

Shown here is Christ Lutheran Church, located on the corner of Second and Harvey Streets. This photograph was taken shortly after the sanctuary was dedicated, in May 1911; however, the congregation was originally established in 1891. An educational wing was later added to the building and dedicated in March 1958. (Courtesy of the Harvey/Ingles Archives.)

Seven
PEOPLE

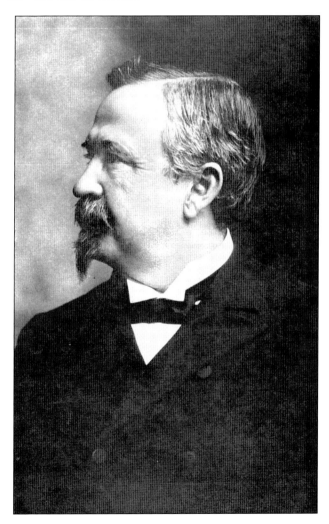

One of Radford's most prominent citizens, James Hoge Tyler served as lieutenant governor from 1890 to 1894 and as governor of Virginia from 1898 to 1902. He was raised on a farm nearby in Pulaski County and enlisted in the Confederate army at the age of 16. Governor Tyler was also a devout Presbyterian who was elected to the General Assembly of the Presbyterian Church three times. (Courtesy of the Radford Heritage Foundation.)

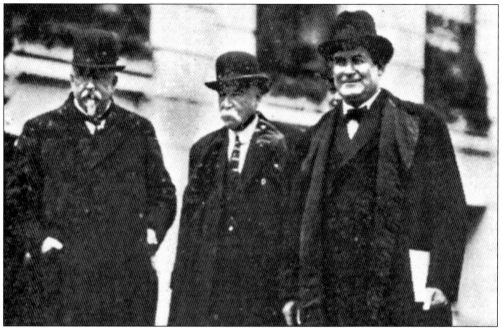

Gov. James Hoge Tyler (left), Capt. Stockton Heth (center), and William Jennings Bryan are likely pictured during Bryan's presidential campaign stop in Radford in 1900. Captain Heth owned a large estate in Radford that was located on property now owned by the university. Radford University's Heth Hall was named for the family, and Belle Heth Elementary School was named for Captain Heth's wife. (Courtesy of the Harvey/Ingles Archives.)

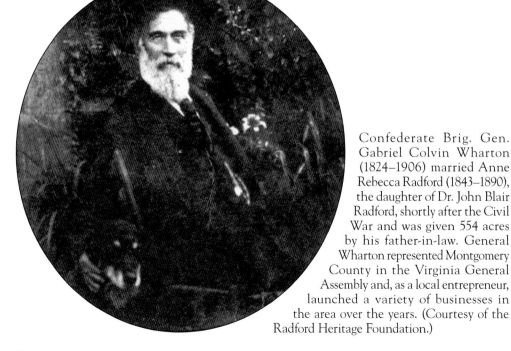

Confederate Brig. Gen. Gabriel Colvin Wharton (1824–1906) married Anne Rebecca Radford (1843–1890), the daughter of Dr. John Blair Radford, shortly after the Civil War and was given 554 acres by his father-in-law. General Wharton represented Montgomery County in the Virginia General Assembly and, as a local entrepreneur, launched a variety of businesses in the area over the years. (Courtesy of the Radford Heritage Foundation.)

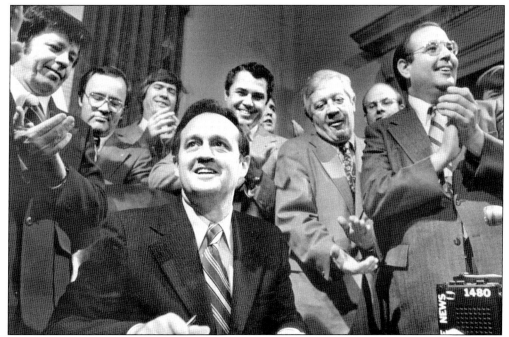

Sitting is John N. Dalton who served as governor of Virginia from 1978 to 1982. The Radford native is shown surrounded by happy northern Virginia legislators as he released $10 million for the metro system in February 1978. Radford's middle school, Dalton Intermediate, was named for the governor. (Courtesy of the Radford Heritage Foundation.)

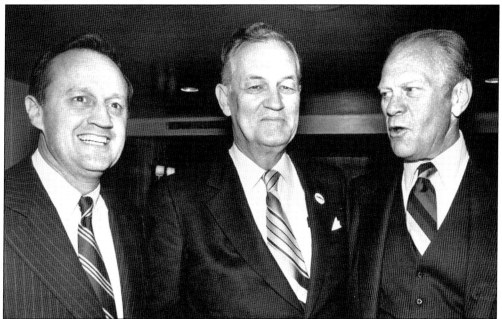

Former Virginia governors John Dalton (left) and Mills Godwin (center) pose with former president Gerald Ford. John Dalton was Radford's second resident to become governor of the state. He died of lung cancer at the age of 55 even though he did not smoke. (Courtesy of the Radford Heritage Foundation.)

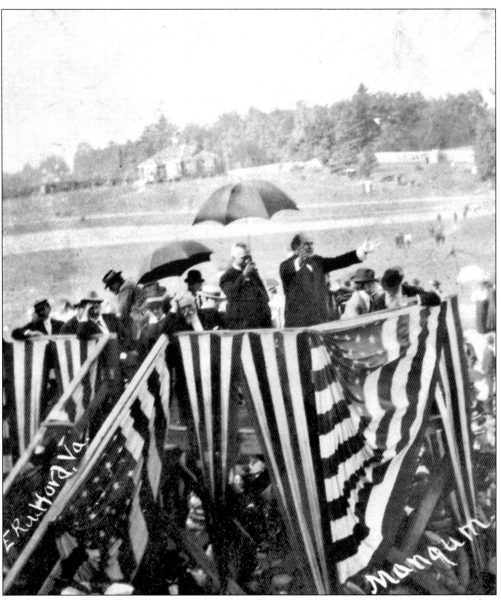

It was a grand affair when Democratic presidential candidate William Jennings Bryan made a campaign stop in Radford and spoke from this grandstand on October 15, 1900. Bryan had three unsuccessful presidential bids in the years 1896, 1900, and 1908; however, he was appointed secretary of state by Pres. Woodrow Wilson in 1913. (Courtesy of Mayor Thomas L. Starnes.)

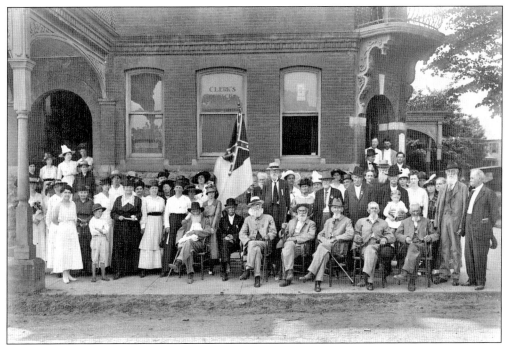

Confederate veterans gather in front of the Radford Municipal Building in the 1890s. General Wharton sits in the first row, fourth from the left. (Courtesy of the Radford Heritage Foundation.)

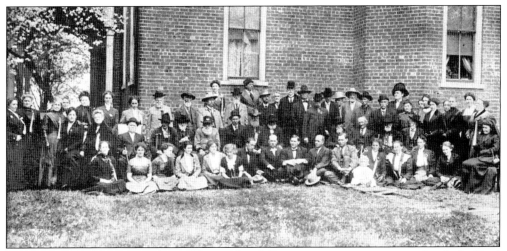

Posed outside of Glencoe are the members of four different organizations associated with the Civil War: the G. C. Wharton Camp, a group of Confederate veterans; the E. M. Ingles Camp of the Sons of Confederate Veterans, which was involved in caring for veterans and widows; and the Radford and New River chapters of the United Daughters of the Confederacy, which shared the mission of preserving the history of the South. (Courtesy of the Harvey/Ingles Archives.)

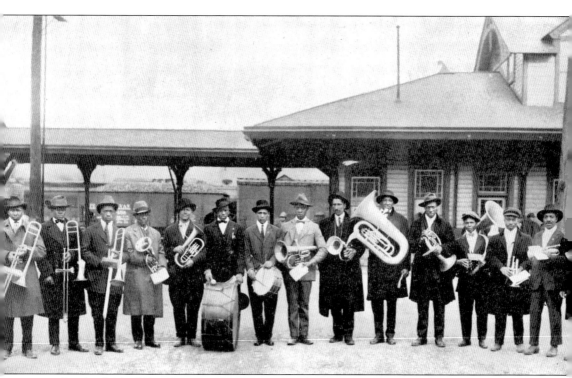

On April 16, 1920—Emancipation Day—this photograph of the Lynchburg Foundry Company Band was taken at the east end train depot. Organized in 1915, the band was composed of Radford Pipe Works employees. Members were reportedly ahead of the times with regard to jazz and could also play a variety of classical tunes. (Courtesy of Leora Caesar and Sarah Carter.)

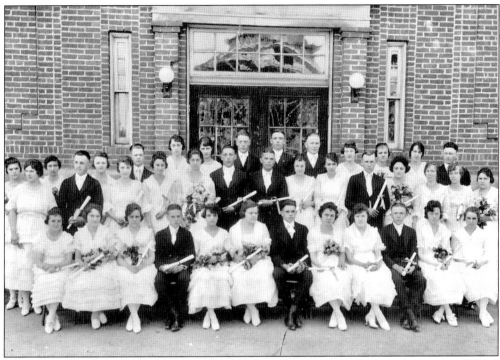

Shown here are graduates of the original Radford High School, located on the corner of Third Avenue and Downey Street. The year of this graduating class is unknown; however, the photograph had to have been taken before 1929, when a new high school was built. (Courtesy of the Radford Heritage Foundation.)

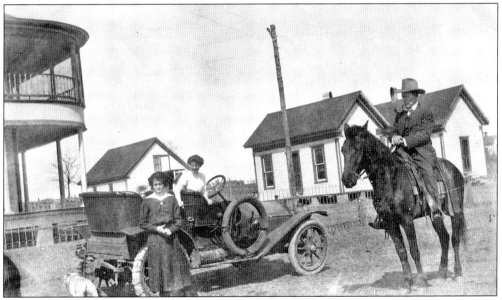

The Vaughn family owned the Radford Fairgrounds and Racetrack. Here J. L. Vaughn rests on the horse while his wife sits in the car and their daughter Doris stands. The family had a large estate in Shawsville but spent a considerable amount of time in Radford overseeing the fairgrounds. (Courtesy of the Ken and Jane Farmer Collection.)

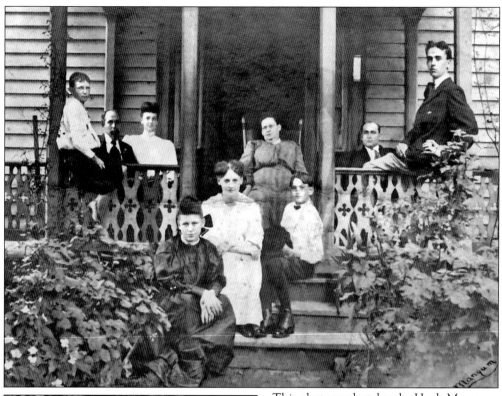

This photograph, taken by Hugh Mangum around 1900, shows the Carden family at their home on Pickett Street in Radford. A renowned photographer, Mangum married Annie Stewart Carden (third from the left) and then established a studio in Radford. (Courtesy of the Radford Public Library.)

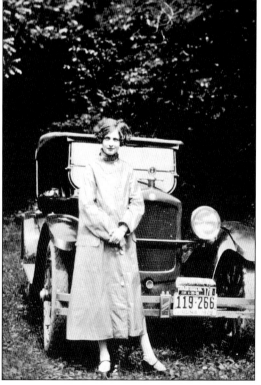

In 1925, Elizabeth Carden poses in front of a Chandler Roadster in Radford. This image certainly captures the feel of the Roaring Twenties and the flapper look. (Courtesy of the Radford Public Library.)

Capt. J. G. Osborne came to Radford in 1883 to assume the position of railroad superintendent. Captain Osborne was a prominent citizen from the 1880s through the early part of the 20th century, and longtime residents of Radford still refer to his home, on the corner of Second and Randolph Streets, as "the Osborne house." (Courtesy of Ken and Jane Farmer Collection.)

Captain Osborne stands by his Cadillac while an unidentified man sits in the driver's seat of the right-hand-drive vehicle. Early Cadillacs were produced this way until 1916, when the company started designing all of their automobiles with left-hand drive, a style becoming more common in the United States. (Courtesy of the Ken and Jane Farmer Collection.)

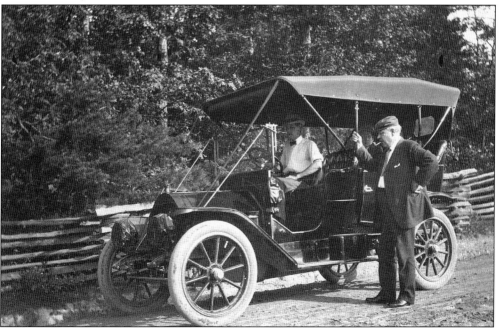

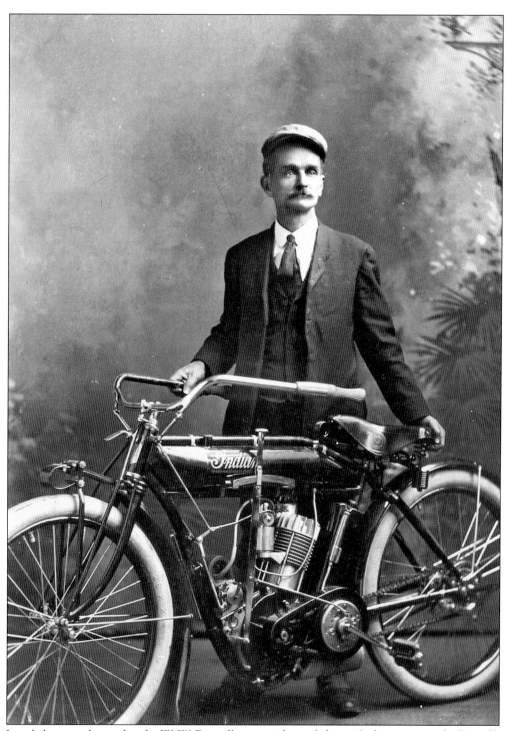

Local photographer and cycler W. W. Darnell poses with a stylish new Indian motorcycle. Darnell, a member of the Radford Wheelman's Club, took many of the photographs from the 1890s and early 1900s that are included in this book. (Courtesy of the Ken and Jane Farmer Collection.)

In 1906, Osborne family members sit in front of their Second Street home, preparing to head off to Roanoke in their Cadillac. This beautiful house still stands on the corner of Second and Randolph Streets. (Courtesy of the Ken and Jane Farmer Collection.)

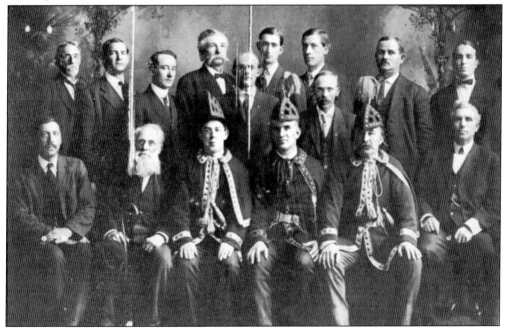

The Ancient Order of the Mystic Chain was a group similar to the Masons and Pythias. Shown here are members of the chapter that was established in Radford at the start of the 20th century. This group was popular in Pennsylvania, though there were few lodges in other states. The order never became widespread and has been defunct since the 1930s. (Courtesy of the Harvey/Ingles Archives.)

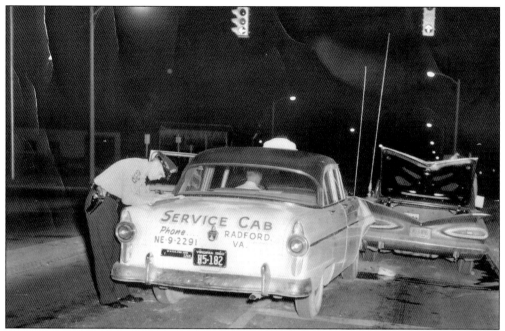

On June 17, 1960, cab driver Millard Osborne and police officer William Spangler had a fender bender at the intersection of First Street and Memorial Bridge. One thing comes to mind when looking at this image: Do not get involved in this type of situation! (Courtesy of police captain Jim F. Lawson.)

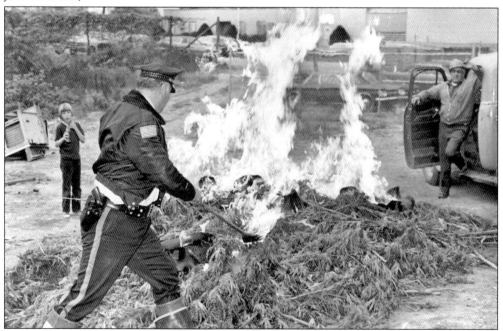

By the early 1970s, marijuana had definitely made its way to Radford. On Wednesday, October 18, 1972, some 850 pounds were found growing in an area that is now a part of Bisset Park. Here a Radford police officer sets fire to the confiscated crop. (Courtesy of police captain Jim F. Lawson.)

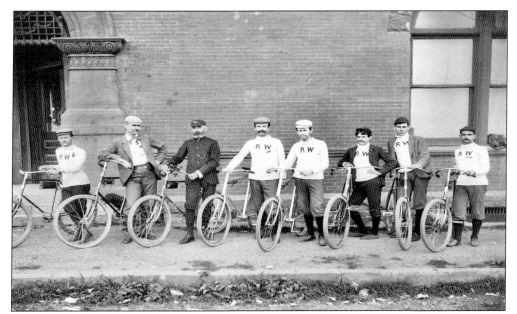

The Radford Wheelman's Club was an athletic group that formed in the 1890s. According to the club's literature, its goal was to "enjoy the sport of cycling as a past-time." Bicycling was becoming quite a popular leisure activity in the 1890s. (Courtesy of the Radford Heritage Foundation.)

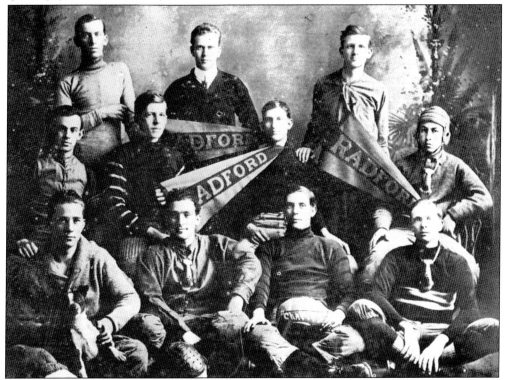

Shown here with its mascot, Dot (the dog in the lower left corner), is the Radford High School football team after the 1912 championship season. The high school's teams did not become the Bobcats until 1933. (Courtesy of the Radford Heritage Foundation.)

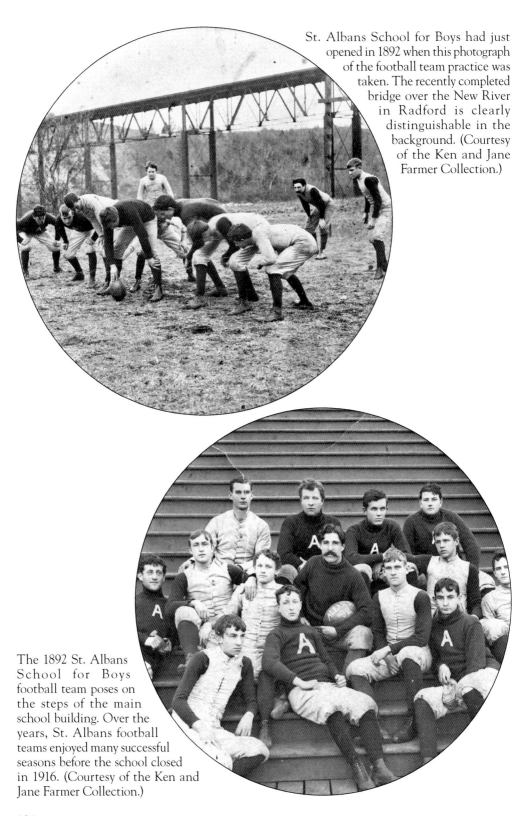

St. Albans School for Boys had just opened in 1892 when this photograph of the football team practice was taken. The recently completed bridge over the New River in Radford is clearly distinguishable in the background. (Courtesy of the Ken and Jane Farmer Collection.)

The 1892 St. Albans School for Boys football team poses on the steps of the main school building. Over the years, St. Albans football teams enjoyed many successful seasons before the school closed in 1916. (Courtesy of the Ken and Jane Farmer Collection.)

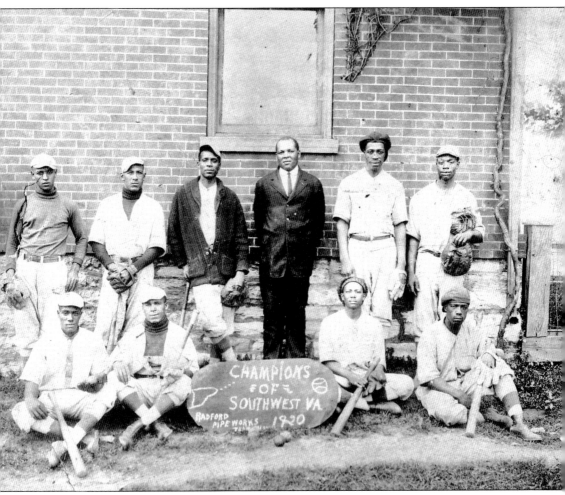

During the era of segregation, blacks were not permitted to compete with whites in organized sporting events. Some private companies organized and supported leagues of African American teams, such as the Radford Pipe Works, whose baseball team won the southwest Virginia championship in 1920. The pipe works, also know as the Lynchburg Foundry, sponsored African American teams through the 1950s. These clubs had quite a following of fans through the years. (Courtesy of the Ken and Jane Farmer Collection.)

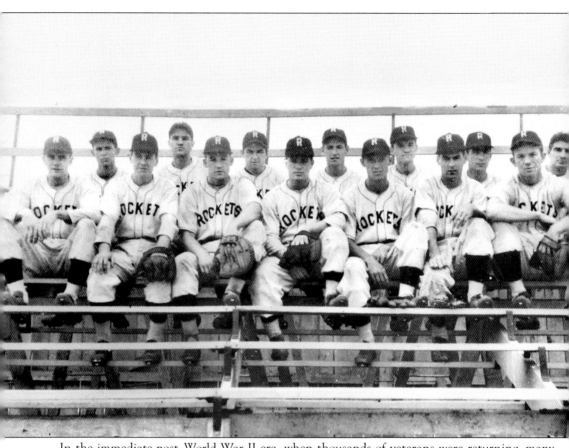

In the immediate post–World War II era, when thousands of veterans were returning, many professional baseball leagues were organized around the country. Shown here are the 1947 Radford Rockets, a part of the Blue Ridge Class D League that formed in 1946. The Rockets were Radford's only professional sports franchise. (Courtesy of Willard Akers.)

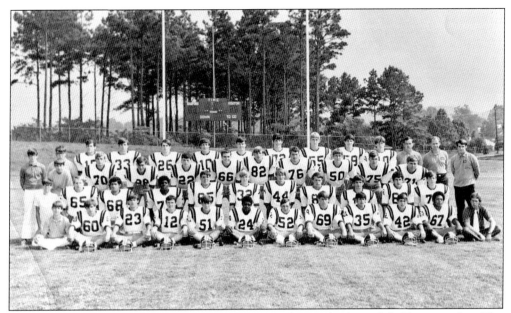

The 1971 Radford High School football team, pictured, won the State AA Championship. The Bobcats went on to win the same honor again in 1972. At this time, Radford had what many considered one of the most-talented coaching staffs ever assembled for an AA high school team. The group was coached by Ron Lindon (fourth row, third from the right), Norman Lineburg (fourth row, second from the right), and Frank Beamer (fourth row, right). (Courtesy of Norman Lineburg.)

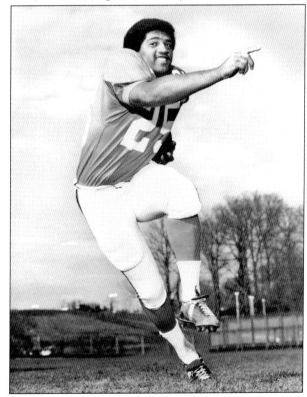

John Dobbins, part of the second group of African Americans to attend Radford High, was a star running back at the school in the 1960s. Dobbins went on to become Virginia Tech's first African American football player in 1970. During his college football career as a Hokie, he rushed for 705 yards and scored three touchdowns in three seasons. (Courtesy of Virginia Tech Sports Information.)

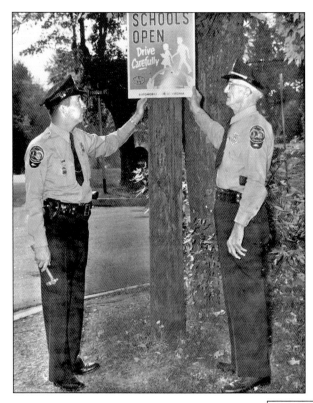

On a warm September day in 1957, police chief Grover Howell (right) and officer Bill Lorton (left) post "Schools Open" signs on telephone poles around town in order to remind drivers to watch out for children. It is unlikely that you will ever see this in Radford again; it is now unlawful to post anything on a telephone pole. (Courtesy of police captain Jim F. Lawson.)

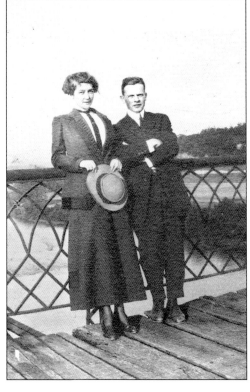

This photograph, taken on the toll bridge about 1916, shows the wooden planks used for the roadbed and the cast-iron railing. Pictured are Evelyn Lyle and Robert Harvey of Radford. Robert was the son of Lewis Harvey, who had purchased the bridge from the Radford Land and Improvement Company. (Courtesy of the Harvey/Ingles Archives.)

Eight
TOWN AND COUNTRY

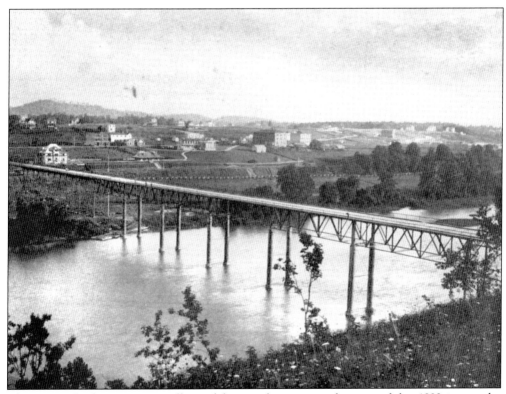

The Wagon Bridge was eventually used for cars; however, at the time of this 1892 image, the gasoline-powered automobile was just beginning to be developed. During this period, locals also referred to the bridge as "the Iron Highway." (Courtesy of the Harvey/Ingles Archives.)

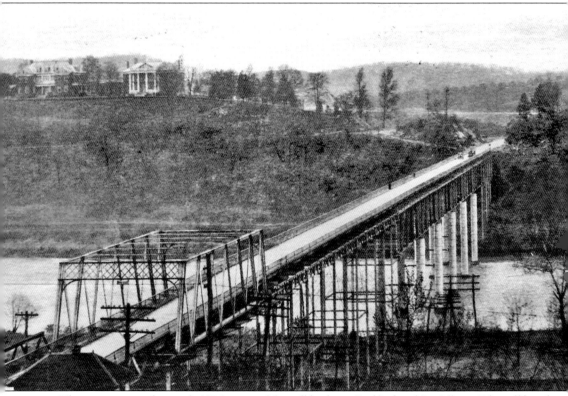

This is an outstanding early-1900s view of the toll bridge at Radford and St. Albans. The toll booth for the bridge can be seen in the lower portion of the photograph. Lewis Harvey purchased the span from the Radford Land and Improvement Company in the early 1900s, and it was taken by the state through imminent domain in the late 1930s. (Courtesy of Mayor Thomas L. Starnes.)

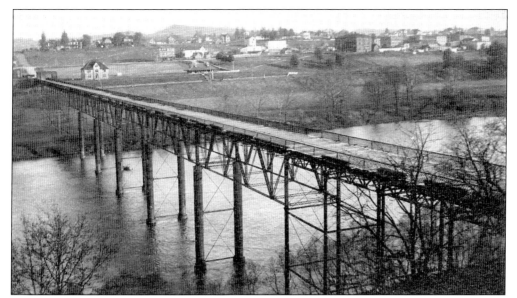

The toll bridge at Radford is shown at the start of the 20th century, along with part of the west end. The Norfolk and Western division office is just to the right of the bridge, and the west end railroad station stands to the right of the office. (Courtesy of the Ken and Jane Farmer Collection.)

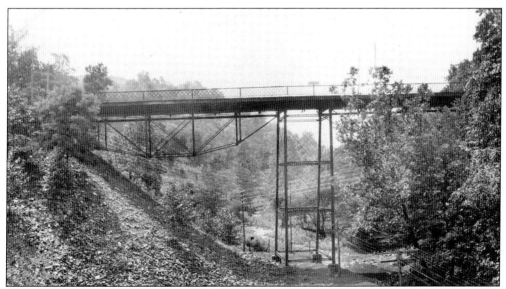

The bridge over Connolly's Run, pictured in the early 1900s, separates the east and west ends of Radford. A WPA project in the 1930s involved adding a culvert and filling this area, thus eliminating the need for a bridge. (Courtesy of the Ken and Jane Farmer Collection.)

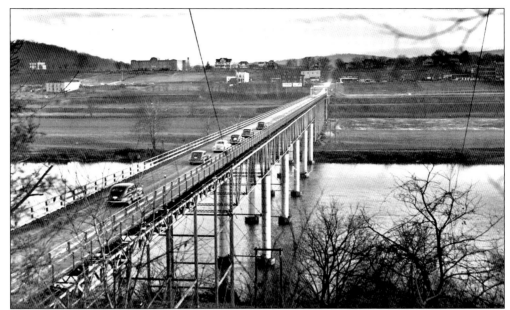

This photograph of the bridge over the New River at Radford was taken during World War II. This span was in use from 1891 until being replaced in 1949. During the war years, it was crucial to the area because the Radford Army Ammunition Plant was located seven miles out of town and on the opposite side of the river. (Courtesy of the Library of Congress.)

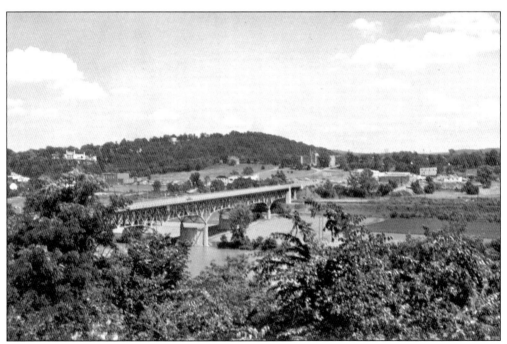

Taken from the Pulaski side of the river, this view provides a good perspective of the central part of Radford in the 1950s. Memorial Bridge, the Governor Tyler Hotel, Radford High School, the Radford Recreation Center, and Arnheim are all distinguishable. (Courtesy of Mayor Thomas L. Starnes.)

Simons Block and the adjacent saloon are shown here at the start of the 20th century, dressed in patriotic decor. The city was certainly patriotic during this period—and for good reason. Several men from Radford had enlisted in the service during the Spanish-American War of 1898, and J. Hodge Tyler, a prominent Radford citizen, was serving as governor of Virginia from 1898 to 1902. (Courtesy of the Radford Heritage Foundation.)

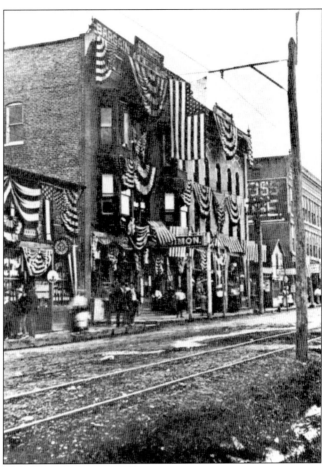

This view, taken during the summer of 1900, displays Main Street in the east end. Again the buildings are patriotically decorated, possibly for the arrival of William Jennings Bryan, the Democratic Party presidential candidate who visited on October 15, 1900. (Courtesy of the Radford Heritage Foundation.)

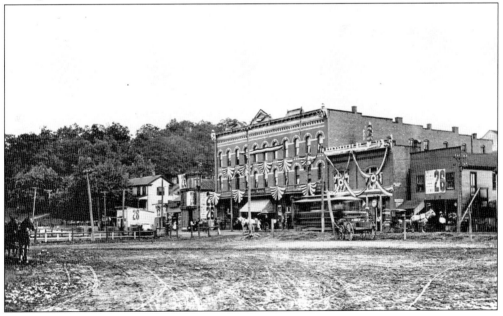

In 1910, the buildings on Main Street in the east end of town are decorated with flags and bunting similar to those in the previous photograph, taken in 1900. A closer look confirms that the decorations are in fact different. Evidently, it was common practice to ornament Radford during this period for political and patriotic occasions such as the Fourth of July. (Courtesy of Radford Heritage Foundation.)

In this 1920 photograph of the east end, the trolley heads west while the Dreamland promotes its new "high class motion picture" theater. Also of interest in this and other old images of Radford is the abundance of beautiful, three-lamp streetlights. An illuminated street was referred to as a "white way" early on in the 20th century. (Courtesy of Mayor Thomas L. Starnes.)

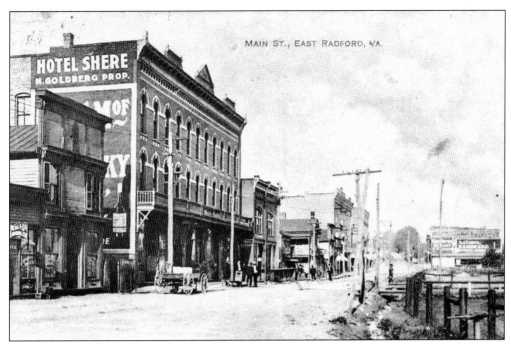

This photograph depicts the east end of Radford in the early 1890s. The city had electricity at this point; however, the streets had yet to be paved and the trolley line constructed. The Hotel Shere was conveniently located across from the train depot. (Courtesy of the Radford Heritage Foundation.)

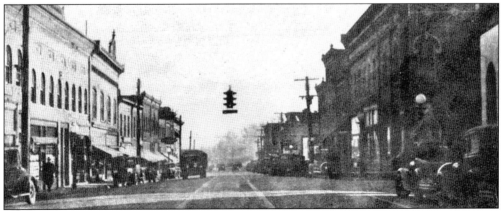

Trolley tracks are visible in this view of the east end business district, taken sometime before 1932. (Courtesy of the *Radford News Journal*.)

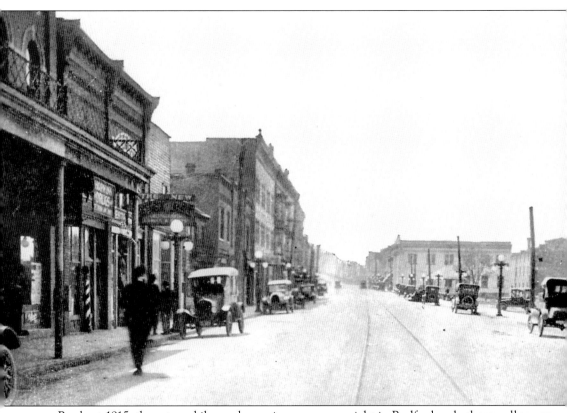
By about 1915, the automobile was becoming a common sight in Radford and other small towns across the country. The main street had been paved for cars, but the trolley was still a major from of transportation. The horse and buggy was on its way to obsolescence. (Courtesy of Mayor Thomas L. Starnes.)

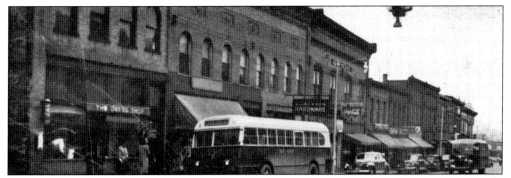

Pictured in this late-1940s image of the east end business district is one of the city's municipally owned buses. During this period of time, the bus system provided safe, economical transportation to all sections of Radford. (Courtesy of the *Radford News Journal*.)

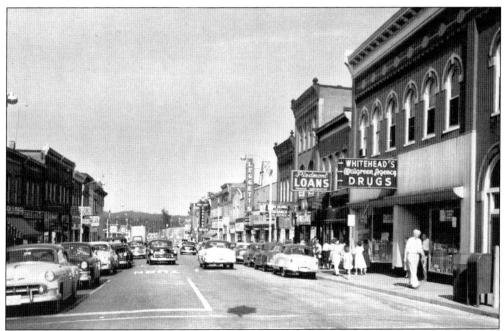

Radford's east end business district is shown in the 1950s. Cars, clothing styles, advertisements, and businesses have changed over the years, yet it remains relatively easy to distinguish this area as the east end. (Courtesy of Mayor Thomas L. Starnes.)

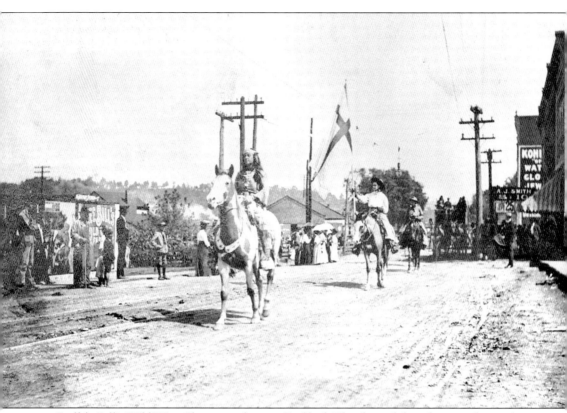
Buffalo Bill's Wild West Show parades into Radford. The date of this photograph is unknown; however, judging by the signs, unpaved street, and utility poles, it must have been taken in the 1890s. The show was on tour for approximately 20 years, from 1883 to 1903. (Courtesy of the Ken and Jane Farmer Collection.)

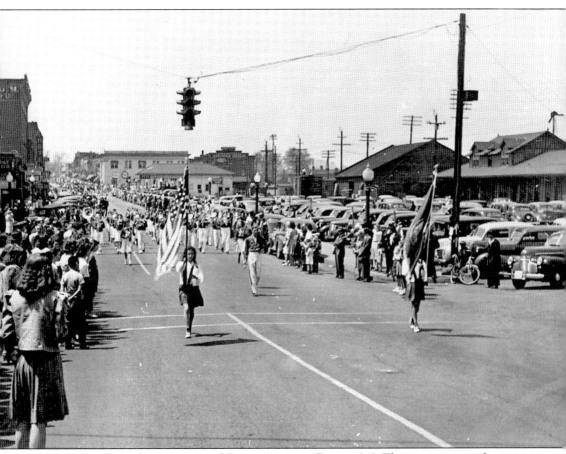
This parade occurred either on Memorial Day or Armistice Day in 1942. The event was significant because the nation had just become engaged in World War II, and patriotism was at its peak in Radford and just about every other small town in the country. (Courtesy of the Radford University Archives.)

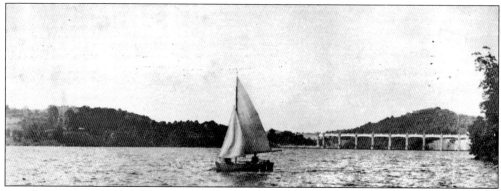

A sailboat glides on Claytor Lake in the late 1940s. During this period, funds were collected from private citizens and businesses in an effort to purchase 437 acres from Appalachian Power with which to create a public park on the lake and surroundings. The money was eventually raised, and in 1951, the Division of State Parks assumed operation of the area. (Courtesy of the *Radford News Journal*.)

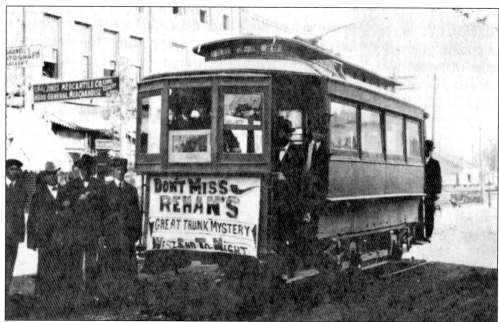

This trolley, seen in 1910, ran from the east end business district to the foundry on the west end. The trolley system was owned by the Radford Electric Light and Power Company, a private utility firm in operation from 1893 until 1923, when the city purchased the business. Soon after the sale, the trolley was replaced by a bus. (Courtesy of the Radford Heritage Foundation.)

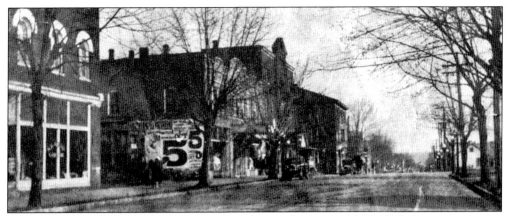
This photograph of the west end business district was taken around 1932. Today's scene is similar, though with alterations in automobiles, trees, and street lighting and the addition of stoplights. (Courtesy of the *Radford News Journal*.)

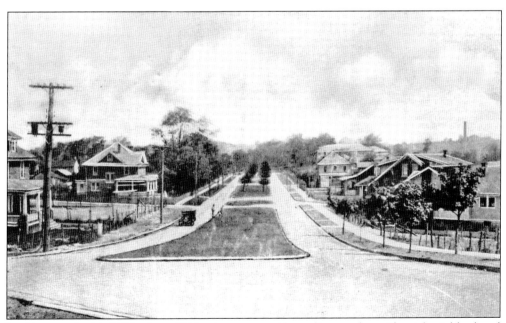
Looking north, this 1920s view of Tyler Avenue provides a glimpse of a residential neighborhood adjacent to a small women's college. It is quite in contrast to the scene today. The university now encompasses the entire right side of the road, and student housing and business that cater to students dominate the left. (Courtesy of Mayor Thomas L. Starnes.)

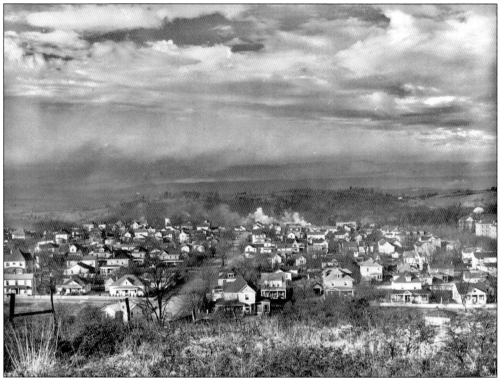

This view of the east end was taken from a hill overlooking the city in the late 1930s. Notice the steam and smoke coming from a locomotive in the Norfolk and Western yard or possibly passing through on the main rail line. In the steam era, smoke and ash from locomotives had to be tolerated on this side of town. (Courtesy of the Radford Heritage Foundation.)

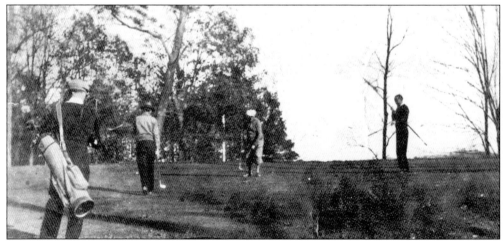

The Radford Golf Club was a nine-hole course established in 1929 on a part of the Kate M. Cassell estate in East Radford. The course boasted a modern watering system and well-kept bent-grass greens. These golfers are pictured on the first green. (Courtesy of the *Radford News Journal*.)

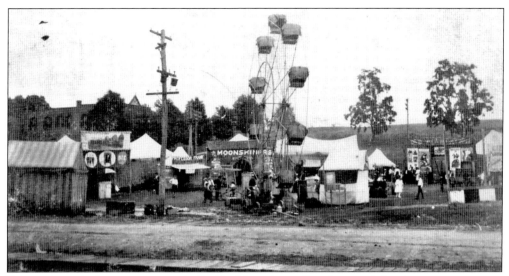

Fairs and carnivals were common in Radford from its earliest days, and the circus came to town annually. Some of these events were held at the Radford Racetrack and Fairgrounds in the west end, while others occurred in an area off Tyler Avenue near Downey Street in the east end. The Radford Carnival is shown here. (Courtesy of Bette Wright.)

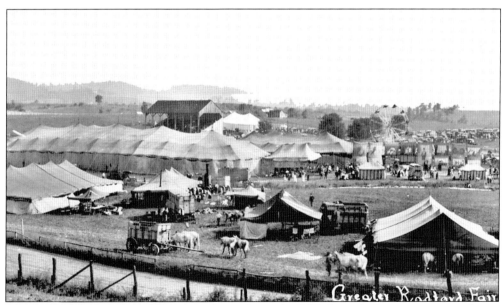

The Radford Racetrack and Fairgrounds was located off Wadsworth Street in an area that is currently between Eighth Street and McHarg Elementary School. The site was a popular attraction in Radford from the late 19th century up until the 1930s, when it was subdivided and auctioned into 176 lots. (Courtesy of the Radford Heritage Foundation.)

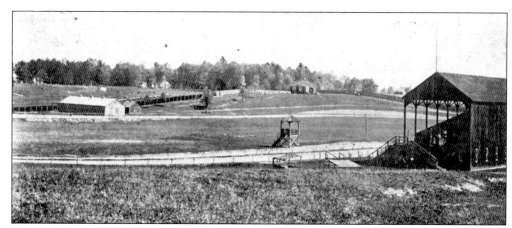

The Radford Fairgrounds and Racetrack, pictured before 1915, was originally owned by J. L. Vaughn. In 1906, the land and facilities were sold to the Southwest Virginia Agricultural and Livestock Association. In 1924, the business was sold again to George W. Reed, who kept the venture operational until his death in 1935. (Courtesy of the Harvey/Ingles Archives.)

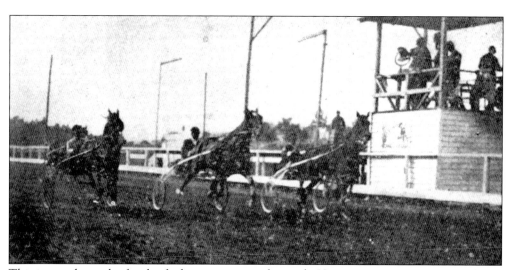

This image shows the finish of a harness race at the track. Harness racing was very popular in Radford, and of course, citizens could place a wager on the action. (Courtesy of the Harvey/Ingles Archives.)

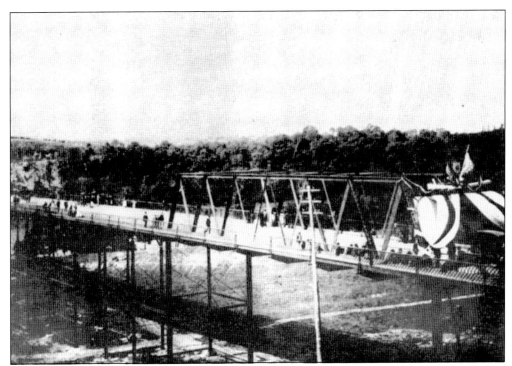

The New River Bridge, or Wagon Bridge, at Radford was completed in 1891 and decorated with flags for its dedication ceremony. An impressive structure for its time, the crossing certainly had a positive impact on the city's growth and prosperity. (Courtesy of the Radford Heritage Foundation.)

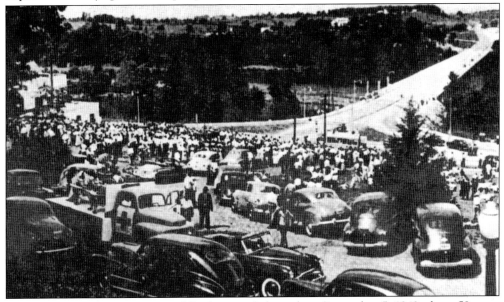

The Southwest Virginia Memorial Bridge was dedicated on September 5, 1949, about 58 years after the dedication of the old Wagon Bridge. The ceremonies began with a parade led by Mayor C. K. Howe Jr. Following Mayor Howe were the 176th Infantry, the Virginia National Guard, veterans groups, and finally a group of students from Radford schools. (Courtesy of the Radford Heritage Foundation.)

This photograph was taken from the hillside overlooking the west end business district in 1900. The West End Hotel (right) and the Ashmead Building (left) were key establishments in the area during this period, and both are distinguishable here. (Courtesy of the Ken and Jane Farmer Collection.)

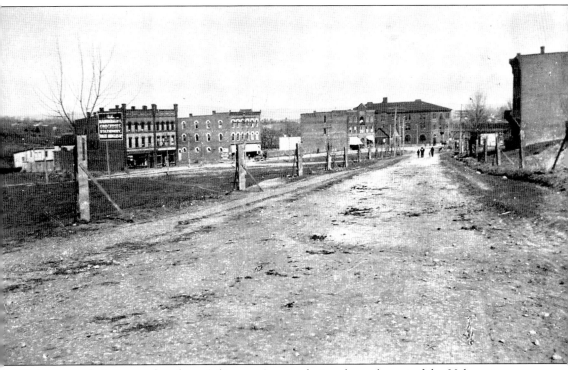

This west end view was taken from Arlington Avenue during the early part of the 20th century. Wainwright's Grocery occupies the building on the far left, and the West End Hotel is discernible on the far right. St. Albans is visible in the far left background. (Courtesy of the Ken and Jane Farmer Collection.)

Discover Thousands of Local History Books Featuring Millions of Vintage Images

Arcadia Publishing, the leading local history publisher in the United States, is committed to making history accessible and meaningful through publishing books that celebrate and preserve the heritage of America's people and places.

Find more books like this at
www.arcadiapublishing.com

Search for your hometown history, your old stomping grounds, and even your favorite sports team.

Consistent with our mission to preserve history on a local level, this book was printed in South Carolina on American-made paper and manufactured entirely in the United States. Products carrying the accredited Forest Stewardship Council (FSC) label are printed on 100 percent FSC-certified paper.